KNOTWORK AND SPIRALS

A Celtic Art Workbook

COURTNEY DAVIS

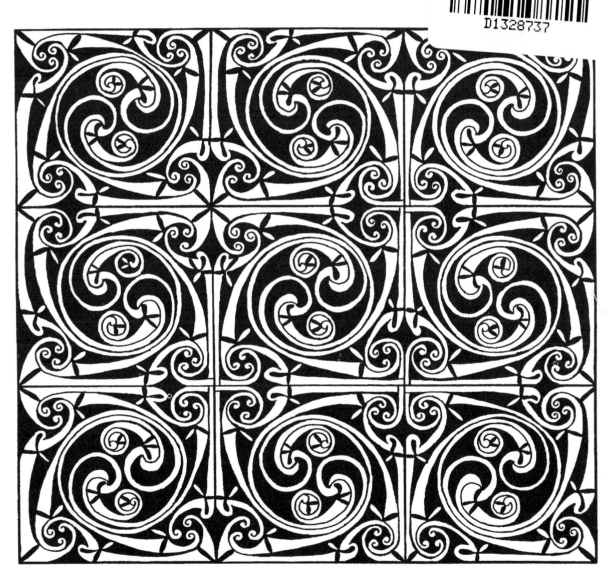

BLANDFORD

ACKNOWLEDGEMENTS

My grateful thanks to Laurence Stroud for his help and guidance
with the text for this book, and to Trish Cardwell for her
encouragement and support.

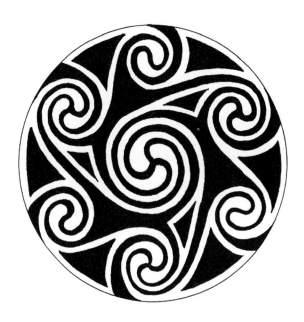

First published in the United Kingdom in 1999 by Blandford

Reprinted 2000

Copyright pictures and text © 1999 Courtney Davis
Copyright design and layout © Blandford

Distributed in the United States by Sterling Publishing Co., Inc.,
387 Park Avenue South, New York, NY 10016–8810

A Cataloguing-in-Publication Data entry for this title is available from
the British Library

ISBN 0-7137-2743-8

Text design Richard Carr
Printed and bound in Great Britain by Hillman Printers (Frome) Ltd, Somerset

Blandford
Illustrated Division
The Orion Publishing Group
Wellington House, 125 Strand
London WC2R OBB

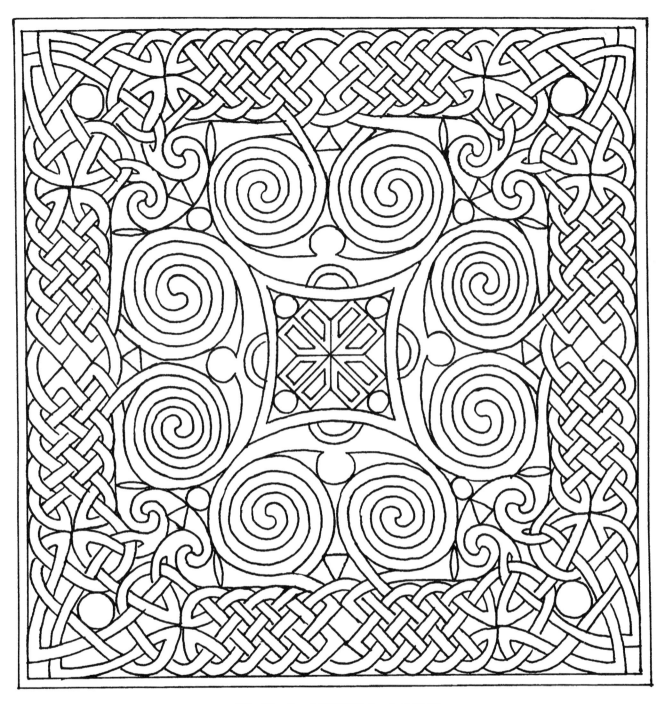

CONTENTS

foreword

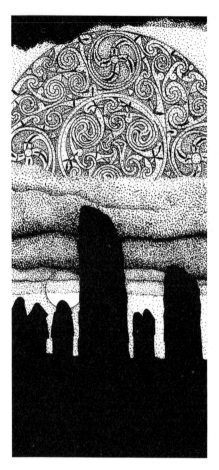

The stones of Callanish, Isle of Lewis, Scotland, c. 3000 BC.

IN THE Preface to his book *Illusions: The Adventures of a Reluctant Messiah*, Richard Bach, relating it to his earlier work, *Jonathan Livingston Seagull*, says: 'The ideas behind the words are simple ones that work in everyday life: find what we most want to do; do it, no matter what; and in the doing be guaranteed a very difficult and a very happy lifetime.'

Courtney Davis has done just that. He has had many years doing what he feels that he has to do. And, as Richard Bach states, '...and in the doing be guaranteed a very difficult and a very happy lifetime'. The 'very happy lifetime' comes in Courtney doing his work, and this shows in his intricate pictures of Celtic art. Difficulties are also something that he personally knows about, along with understanding and compassion; he is a man who knows how his work can be so very therapeutic to the people from many walks of life who need it. At some of his exhibitions we have incorporated 'healing sessions', by encouraging the public to participate in colouring his pictures with their own individual ways of expression. Thus they were able to find an outlet for their innermost feelings; Courtney and I were there to encourage them to express themselves and to 'feel the moment'.

Anyone who has read Richard Bach's wonderful books cannot help but arrive at the understanding of life as conveyed by the written word. I am not making a direct comparison with Courtney but would like to say this: Courtney's treasures are in the subtlety of understanding. If one allows oneself to look at the entirety of his work, we see the reality of the beginning and the end, what *life is*. Where we, in our material form, are restricted to physical things and understanding the everyday, our thoughts and inspirations look at the other life beyond.

Courtney has done exceedingly well to bring this most ancient art form into our lives. I feel sure that those who read this book and appreciate the true artist that he is will find a deeper reality and the eternal living artist within their own being.

Laurence H. Stroud, Polgooth, Cornwall

KNOTWORK AND SPIRALS

A Celtic Art Workbook

DEDICATION
To the Celtic spirit and the inspirers and masters of the past.

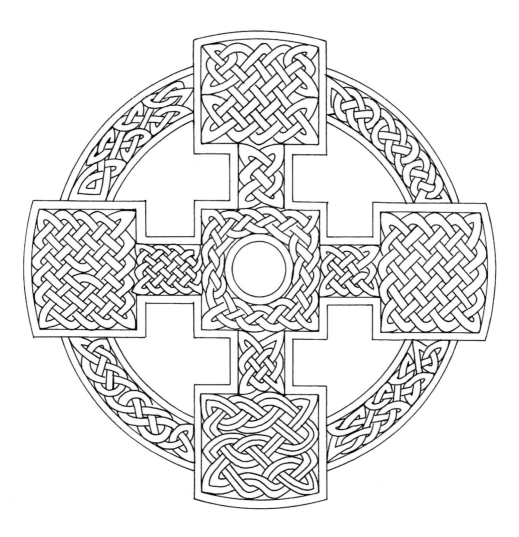

A cross based on the Conbelin cross-slab,
Margam Abbey, Wales, c. AD 900.

Title-page:
This spiral panel has been adapted from a section of a carpet page
in the seventh-century Lindisfarne Gospels.

Copyright page:
The spiral motif has its roots in pre-Christian times and adapted forms
of the pattern above can be seen on metal, stone and parchment.

Contents page:
The ideas for knotwork and spiral patterns come from various sources.
Both types of design symbolize our journey through life and beyond.

INTRODUCTION

IN THE twenty years of producing many hundreds of paintings and black-and-white illustrations in over thirty books, it is not surprising that the magic and mystery of the images I create permeate my world. There have been moments when I felt myself falling into them and have grabbed my drawing-board with a start as if awakening from a dream.

This workbook and its companion volume, *Key Patterns and Animals*, grew from the successful adult courses I have run in the past where people from all walks of life have sat for hours colouring in my mandala images. Many people, who hadn't touched art since childhood, were able to switch off from the outside world and become children again. The book was created specifically as an inspiration and a tool for artists young and old, whether as dabblers or whether proficient in drawing and painting. The potent powers of the symbols in these pictures have been used by people for thousands of years and are still as strong and as relevant to us today as in the past. They are reflected in the natural world that is all around us and in unseen movements of energy that can be sensed through healing and dowsing. I live in a world where it is unusual *not* to feel unseen hands resting on my shoulders as I work, and lights touching the paper to guide my pen and brush.

The monks of the past must have often looked from the windows of the scriptorium and viewed the rhythmic movement of the thundering sea crashing against the rocks, which were often at the very foot of the monastic

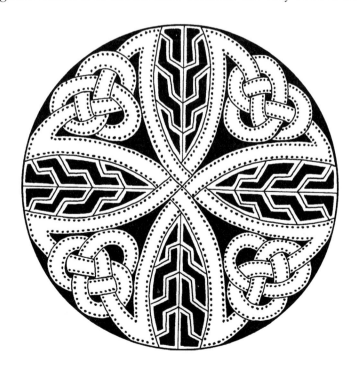

A pattern from a carpet page in the Book of Durrow, seventh century AD.

7

walls. They could reflect upon the cyclic changes of nature as it moves through each season and the constancy of the cycle of life, death and rebirth echoed in the pre-Christian and Christian festivals. Johan Quanjer says in his Foreword for one of my previous volumes, *The Celtic Art Source Book*:

> *Through symbolism we can see the soul of man awakening to the realisation of his true purpose, leading him to a higher level of conscious awareness. The novice is often unaware that we are surrounded everywhere by symbols, the most obvious one being the sun. This is an ancient universal symbol of light. On the physical level it is the bringer of life to this planet, the force that creates, stimulates, renews and heals. On a spiritual level it represents the solar logos – the word of God, the representative of the Godhead for our solar system.*

COLOUR

Life is full of colour and the use of colour in our lives can either uplift us or depress us. We are known to have a 'blue mood', we 'see red' if we're angry, we have 'black moods', can be 'green with envy', 'in the pink' or 'seeing the world through rose-tinted glasses'. We feel uncomfortable when wearing certain colours and blame them because they seem to drain our energy or bring us bad luck. Colour can be a very powerful tool. For a long time my paintings had hardly any green in them as I couldn't mentally fit it into my paintings; I wouldn't even wear clothes with any green in them. With the many changes in my life over the last eight years I suddenly discovered in 1994, while I worked on my book of Celtic mandalas (see Further Reading, p. 63) that the colours I used on my palette started to change. I created a large painting called the 'Emerald Cross', with which I was very pleased. I am now completely at ease with green and it has become one of the most prominent colours in my work.

Colour is one of the most universal of all types of symbolism. In Jungian psychology blue is associated with the clear sky and stands for thinking. In the art of the Middle Ages and Renaissance the Virgin Mary's robe was usually shown as blue, probably because of her role as Queen of Heaven. Yellow and gold stand for the sun, intuition and illumination, red for blood and emotion (see colour picture 12 and how powerful the use of this colour can be), orange represents fire and purification (the use of orange in different intensity creates the illusion of a fire at the centre of colour picture 5) and green is a soothing and restful colour (see colour picture 2), which embodies nature, growth and fertility. Green also predominates in Christian art because it is a bridge between yellow and blue.

The positive and negative aspects of colour are symbolized in medieval Christian art where black, associated with night and darkness, stands for

penitence and death while white represents charity and love, symbolized by images of Christ's resurrection on Easter Sunday. In the early Celtic portraits the ruling classes are shown with long flowing golden locks (though often with brown beards) and the enslaved classes are shown with short black or brown hair. In a darker kind of symbolism, saffron-yellow vestments were worn in earlier times in churches on Good Friday as a reminder of those who crucified Christ. Judas was shown in medieval paintings with reddish-yellow hair, symbolizing jealousy and hate. The intensity of colour and its purity correspond to the purity of the symbolic meaning. Primary colours represent primary emotions and mixed colours express a more complex symbolism. Purple, a mixture of the fire of red and calm, thoughtful blue, represents power and sublimation (in colour picture 3 its use uplifts the image) and it is the colour of cardinals' robes. The use of red and green work well together (see colour pictures 1, 4, 5, 6, 9 and 10), and both are symbols of life. In prehistoric times people believed that blood had the ability, if smeared on to an object, to bring things to life, and in death red ochre was sprinkled on the corpse apparently to give life in the afterworld.

The basic colours made from pigments, used on most Celtic manuscripts, were red, blue and green. The pigments used by the scribes or illuminators, who were monks, came from various sources: plants, animals, minerals and so on. For example, indigo was obtained from the roots of a plant from India; black was made from the soot of burned bones; and raw sienna and yellow

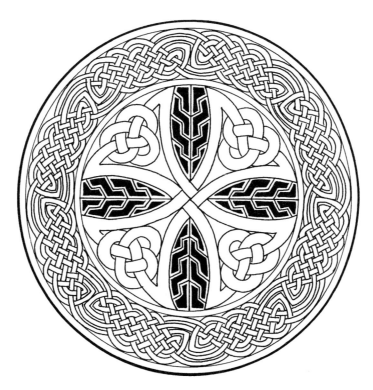

This image is adapted from the central medallion of a carpet page
from the Book of Durrow.

ochre came from natural earths. The pigments used by the monks had brilliance and a luminous quality; they were easy to apply by quill or brush and the colours lasted, apart from ground malachite (green) and azurite (blue), which would fade or discolour unless enclosed within a suitable acid-free binding. The illuminators learned these facts over the centuries and many references to the appropriate tempering of different pigments occur in their 'recipe' books. Genuine ultramarine blue – made from lapis lazuli, a semiprecious stone from Persia (modern-day Iran) and Afghanistan – was the most prized of the pigments used by the illuminators. Second to this was azurite blue (*azzurro della magna*). Both were ground down to make the pigment and mixed with a medium of egg yolk and water. If properly prepared, the colour was neither too green nor too purple but a deep blue, and very opaque.

I have always felt that the Celtic illuminators and craftsmen would have certainly enjoyed the art tools, materials and colour range we have today, and would have used them to full effect. The illuminated pages of the gospels were produced so as to be a visual celebration of the glory of God and even with as few as the four or five colours sometimes used the pages still look magical.

USING THE BOOK

Above all, this is meant to be a practical book. The illustrations on the following pages are especially designed for young and old alike to adapt and colour for their own use. I suggest that, when you have chosen a picture to paint, instead of colouring it in the book you should photocopy it, either larger or reduced – whichever suits you. You could also copy the patterns freehand or trace them, adding or discarding parts from various pages until you eventually have your own unique picture. You could use felt-tip pens, pencil, ink, gouache, watercolour or even embroidery thread. I always use gouache in my work because I create the detail in my pictures as I go and this medium gives me the ability to cover over one colour with another when I need to make changes. With gouache I can lay a background colour over the whole sheet of paper, using a sponge or cloth to give the effect of stone, and I can then build the pattern on top. Images such as colour pictures 2 and 8 work well like this because of their simplicity.

Some of the patterns in this book are adapted from the illuminated pages of Celtic manuscripts and the carvings from the various stone crosses that cover Ireland, Scotland and Wales. Others are created from very rough doodles with pencil and pad, which I have gradually built up over a period of time and constantly refined until they feel complete. Although I have produced some pages showing grids I do not use them myself. For my own work I start with a rough outline and build it up as a whole; the final finishing is created as I start painting. Many people who have grappled with

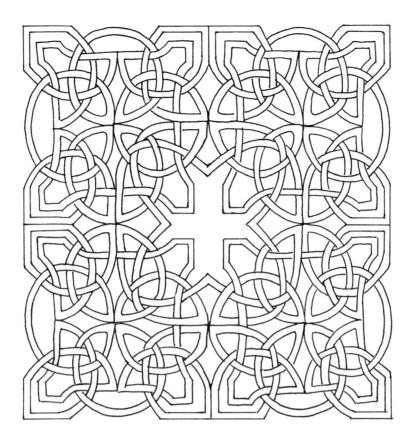

A cross built from a continuous thread can easily be linked to additional panels.

the system of grids contact me. Having failed, they are put off from persevering with the patterns. There are excellent books (see Further Reading, p. 63) that deal with the methods of constructing the patterns. I always suggest to people that they should put aside the books if they feel that they hinder the spirit within, and just play with the lines until an overall pleasing pattern is formed. Then you can spend time embellishing and readjusting your work. Once you have got to grips with the general idea of the rhythm of the patterns you can return to the books if you need to, and continue with a greater understanding of the mechanics of the craft.

People always ask me what colours they should use and I always suggest that they should experiment. Personally, I never pre-plan the colour of my paintings. In fact, my paint palette changes from day to day, like my mood, and I always let the picture lead its own way. The colour examples in this book are meant as a guide only; if you like a certain combination of colours you could perhaps adapt them for use in another picture. I like experimenting all the time. Sometimes the colours don't work, but when something unusual is successful it is very satisfying. Practise using different colour combinations, and don't tie yourself to rigid colour schemes.

I hope you enjoy the book. Remember to be yourself, and don't worry if your first pictures are a disappointment. I know that working on a picture can be very frustrating as the image you 'feel' inside doesn't always get relayed to your hand. If you persevere and just let your pen and brush, or other medium, flow naturally you will be surprised at what you can achieve.

knotwork

INTERLACE BORDERS and panels, based upon the plaiting art of the Chinese, go back as far as several thousand years BC. Most peoples surrounding the Mediterranean, the Black Sea and the Caspian Sea, Egyptians, Greeks, Romans, Byzantines, Moors, Persians, Turks, Arabs, Syrians, Hebrews and North African tribes have also used this art form in one way or another on stone, metal and wood. Celtic knotwork designs, though to many the essence of Celtic art, were actually the last to make an appearance.

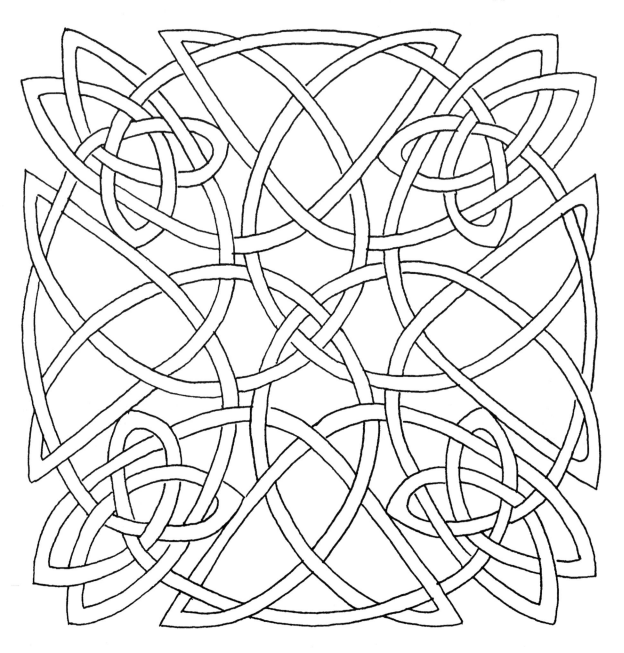

A cross built from a continuous thread that was created from a rough doodling. The panels of the cross could be filled with dots to flesh it out (see colour picture 2), and the cross could also be turned around to create a different design.

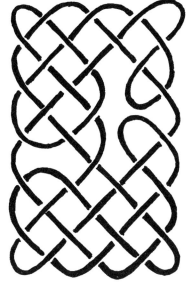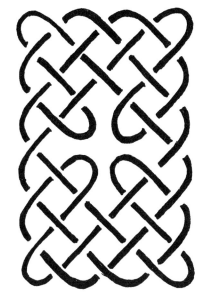

| Regular plaitwork. | Irregular broken plaitwork from the cross-shaft at Golden Grove, Carmarthenshire, Wales, eighth century AD. | Here the plait begins to get broken up at regular intervals and ceases to be the most prominent feature. |

The only interlaced work in Egyptian, Greek and Roman decorative art was the plait, which was never modified. The simple plait evolved in time into all the knots commonly used in Celtic art. There are eight basic knots, identified by J. Romilly Allen in his book *Celtic Art in Pagan and Christian Times*. He believes these were the root of all Celtic interlace.

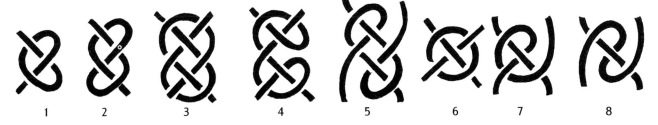

1 2 3 4 5 6 7 8

Scholars think that the first cross-slabs to appear with multi-strand interlacing date from around the seventh century AD in Scotland and Ireland, the most famous of them being from Carndonagh and Fahan Mura, Co. Donegal, in Ireland. Through the centuries the Celtic crosses and stone slabs became decorated with very complex interlaced patterns and other equally intricate decoration, and were painted with bright colours.

The earliest knotwork on stone slabs, metalwork and manuscripts followed the rules of a continuous ribbon of knot; in later manuscripts the continuity was not insisted upon. In the middle of the seventh century AD the first interlacing appears in insular book decoration on the colophon page

at the end of St Matthew's Gospel in a fragment of the Durham Gospels. This page has an unusual shape of three Ds, one on top of the other. The ability of the knotwork to expand or contract, like liquid filling a designated passage by adapting itself through necessary change in its pattern, made it a useful decorative tool for the Celtic illuminator, whose skill gave it new dimensions of intricacy.

Celtic interlace lasted longer through the centuries than any other style used by illuminators and was invariably the decoration that would be chosen, rather than spiral, key patterns or zoomorphics, if it was to be used by itself to decorate large areas of vellum and stone. The panels below are from the Book of Kells, *c.* AD 800, and you can get a better idea of how they were created if you work from the grid systems, completing the patterns as a ribbon. From here you can construct the final interlace in either a single or a double band.

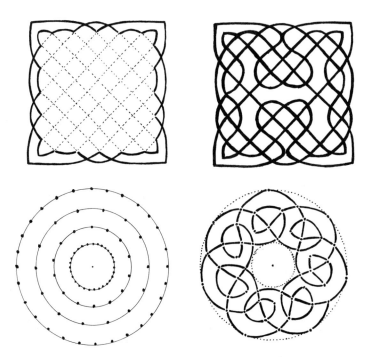

Ian Bain suggests, in his book *Celtic Knotwork*, that it was possible that the Celtic artists would have created a mystique around the creation of Celtic art in both pagan and Christian times. Keeping the construction of the designs a closely guarded secret gave its practitioners similar powers to those of the magician, medicine-man or miracle-worker in the eyes of the beholder.

The 'Thread of Life' weaves its way continuously, as it has done from the very beginning, to end and to begin yet again. Life is the knot of the individual being. The unceasing unfolding of each of us can be seen in the knotwork patterns where past, present and future flow in an endless tapestry of life, each of us contributing towards its construction and to its design in our daily lives.

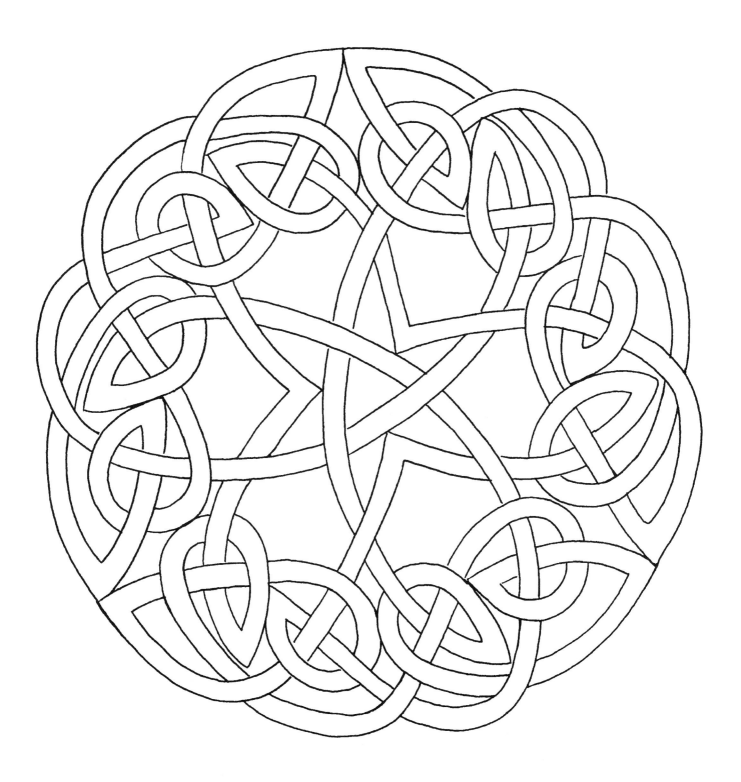

This pattern began from a simple knotwork border. I then pulled out selected bands to create the six-pointed star at the centre.

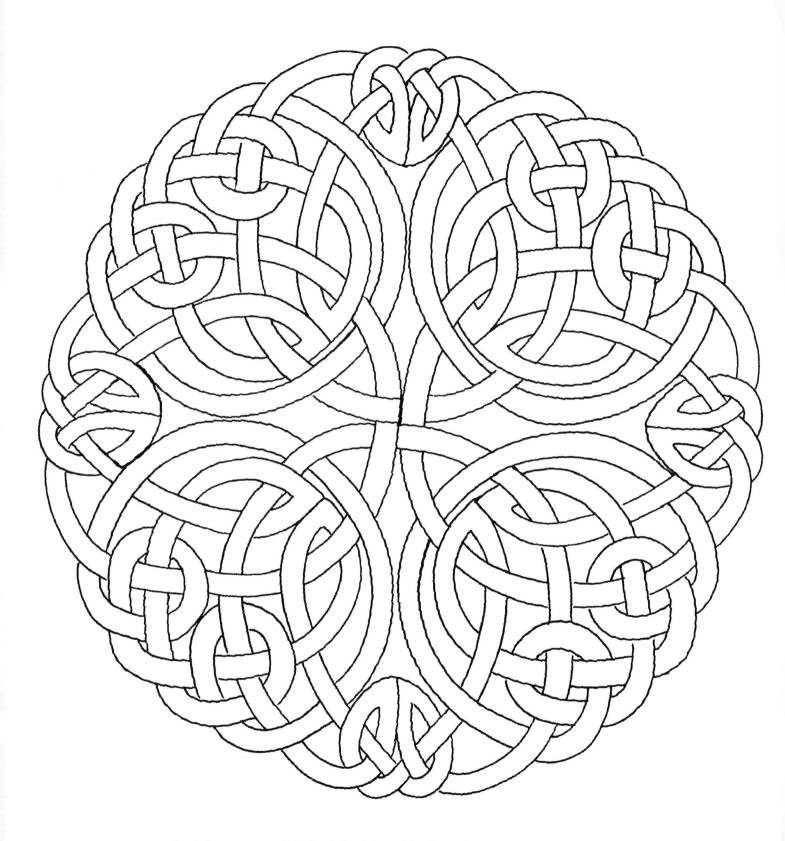

Derek Bryce suggests, in his book *Symbolism of the Cross*, that a knotwork pattern symbolizes
continuity of the spirit throughout existence and has similarities to the continual background note
or drone maintained behind the music of bagpipes.

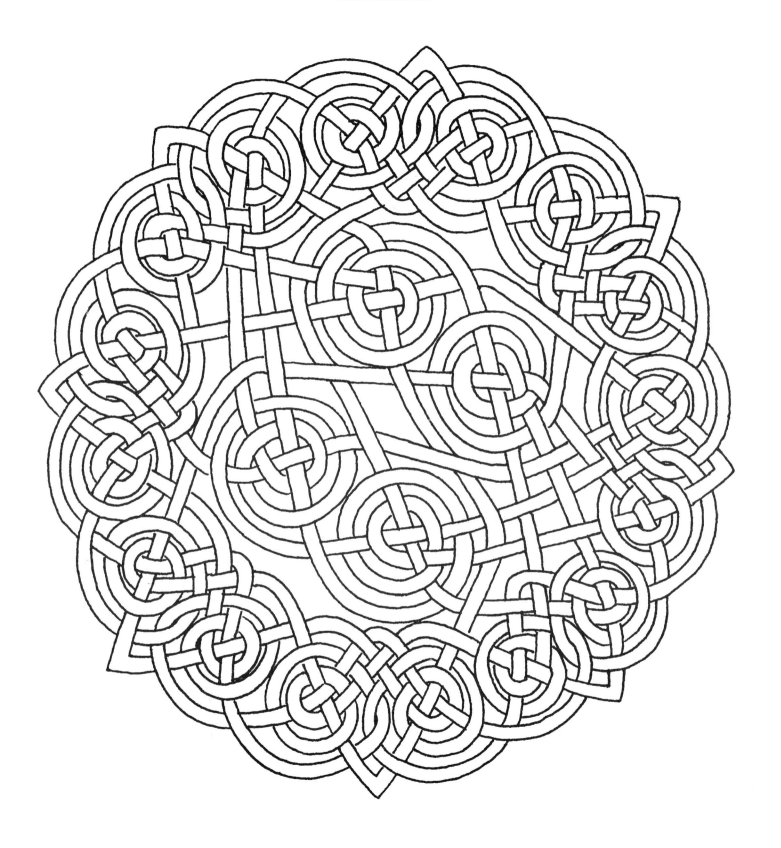

This pattern has its roots in what the author George Bain called 'Viking loot'
found on the Isle of Lewis, Scotland.

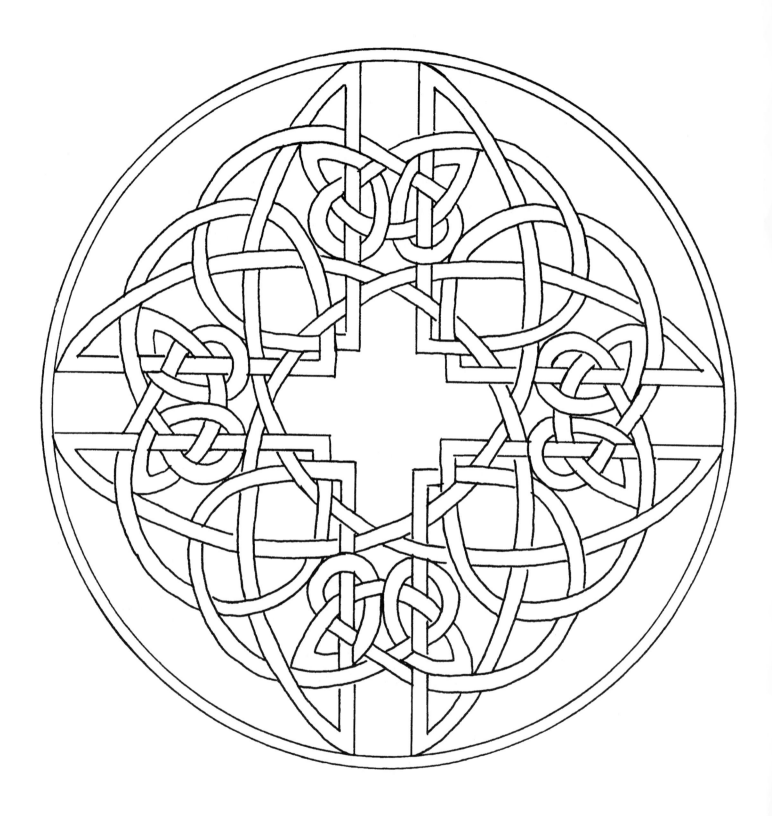

There are very few peoples who did not use some kind of interlaced pattern, derived from plaiting or weaving, in their decoration on stone, metal or wood.

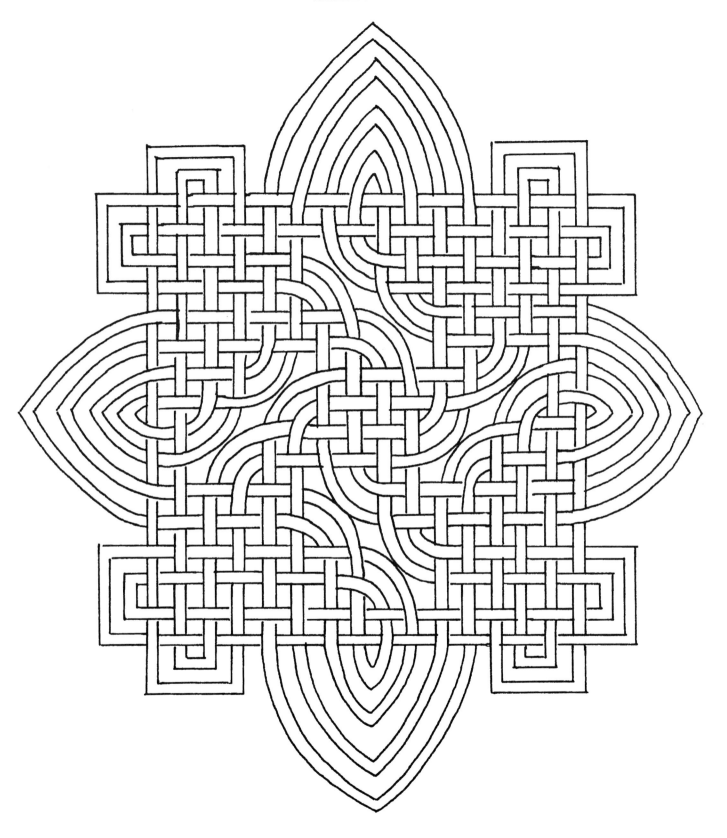

This design originally came from the Book of Kells and was used four times in various forms on one page. The image is taken from a panel that had lion heads at each corner and was incomplete. By copying and tracing through I finally managed to complete the design with my own adjustments.

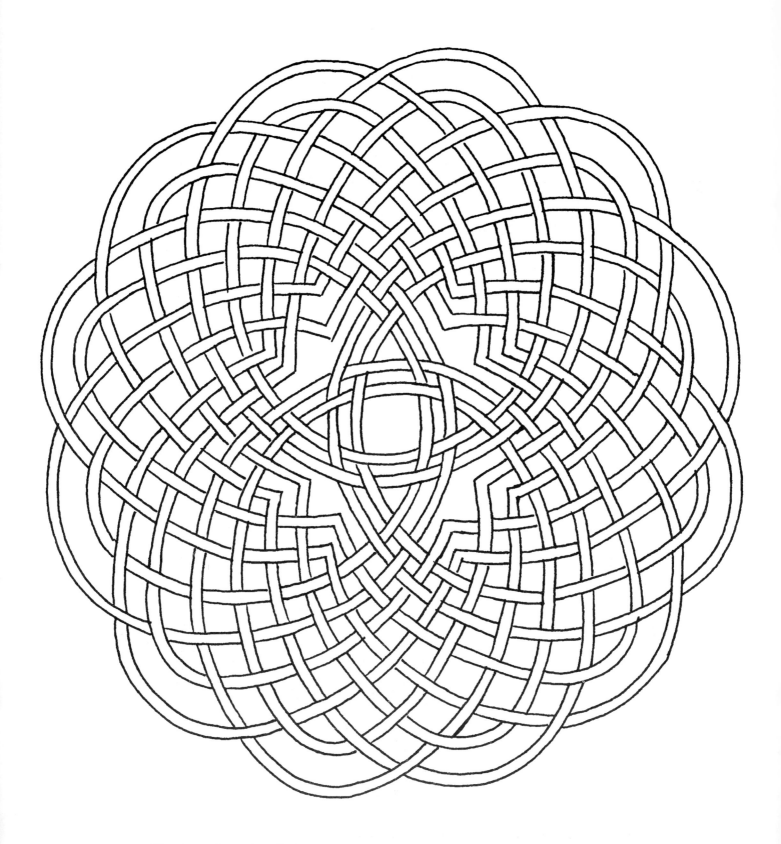

This design also works well when creating a rainbow effect by colouring. You could, as well, pick out
four of the panels into the form of a cross (see colour picture 3).

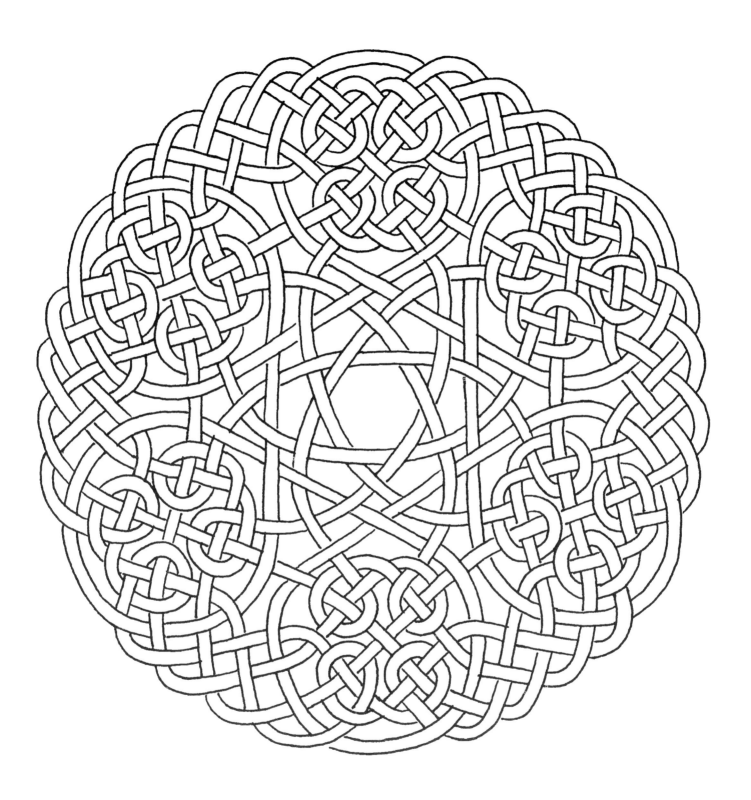

This design originally started from a pattern that was used on the Angus stones of Glamis, Collieburn and Sutherland in Scotland. I joined six of these patterns in a circle, and drew off some bands to create the centre. For a coloured version see colour picture 4. You could add another thin line in a slightly darker colour so that the picture becomes three-dimensional.

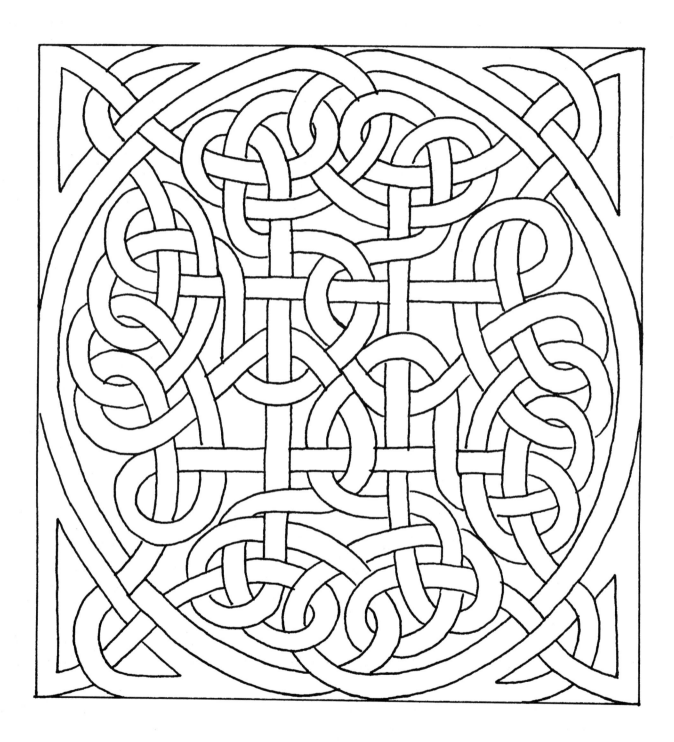

Derek Bryce suggests, in his book *Symbolism of the Cross*, that the breaking of knotwork patterns and then joining them in different ways may have been the artist's way of imitating nature. He explains that although a flower may look attractive and symmetrical, not one of its petals is exactly identical with another. Perfection belongs to God alone.

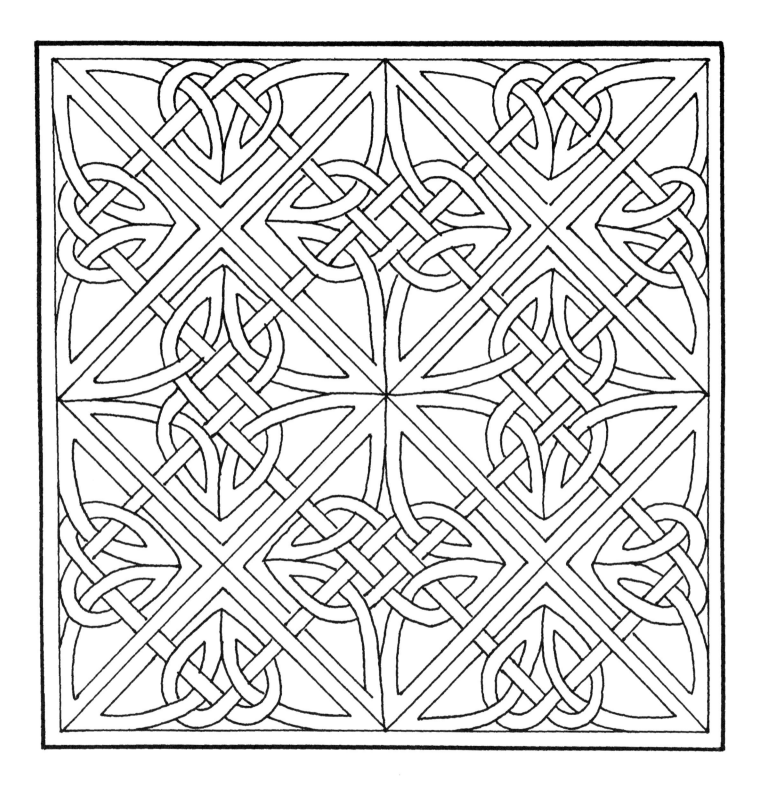

This pattern had its origins in the carving of the Ulbster stone, Caithness, Scotland. I used each
panel four times and linked them together. Further adaptations could be made in the centre.

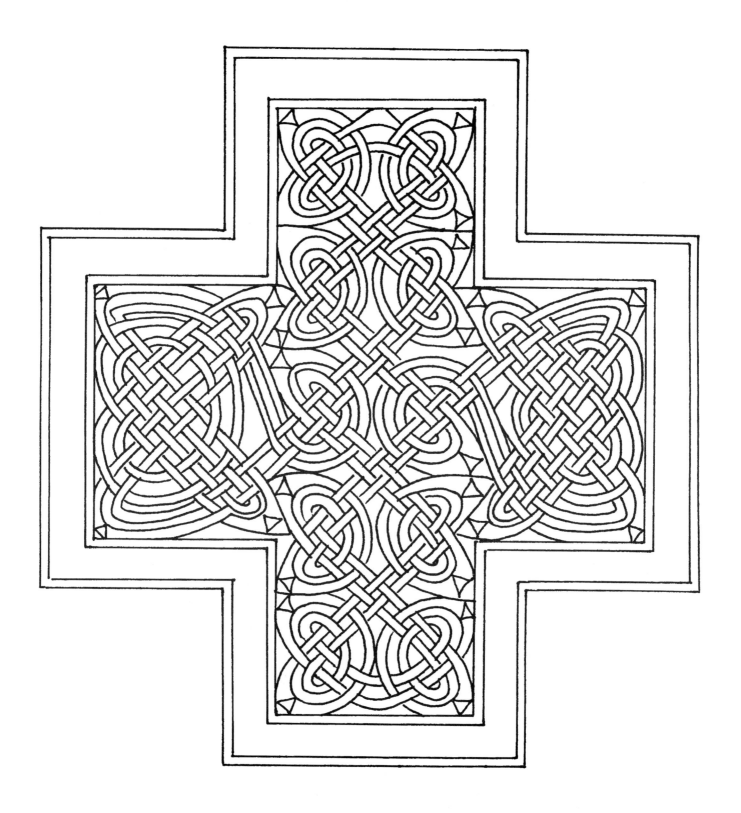

The pattern above comes from the Book of Kells, c. AD 800.

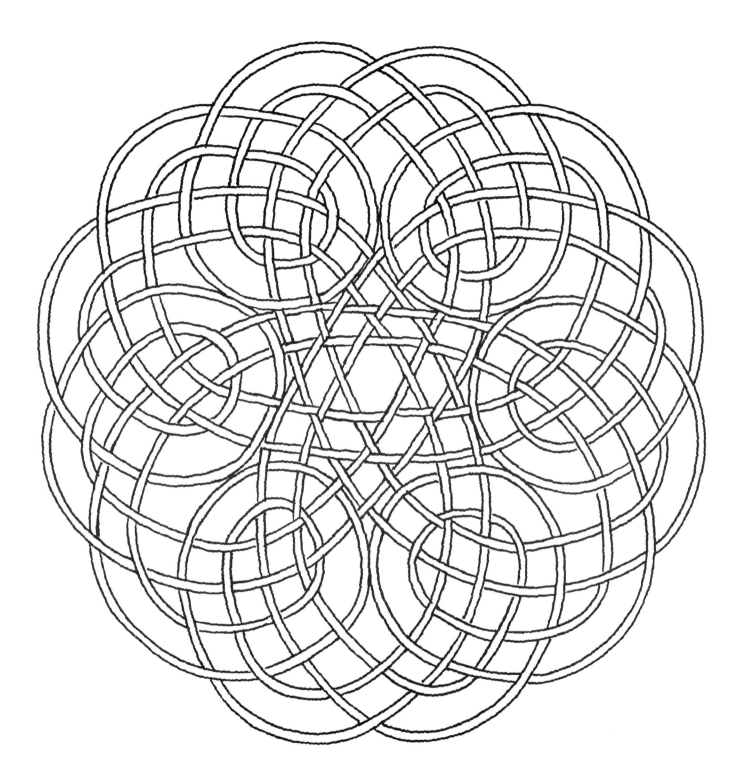

This pattern is an adaptation taken from the Hilton of Cadboll stone, Ross-shire, in Scotland. I altered it by doubling up on the bands and creating the six-point star in the centre. I often use a star at the centre as it gives a good focus for the picture when it is coloured (see colour picture 5). In the coloured version I added blue dots around the pattern (in the Celtic illuminated gospel-books they would normally have been red). If the bands were made thicker you could fill them with dots of different colours — perhaps changing from light to dark as they follow the flow of the knotwork.

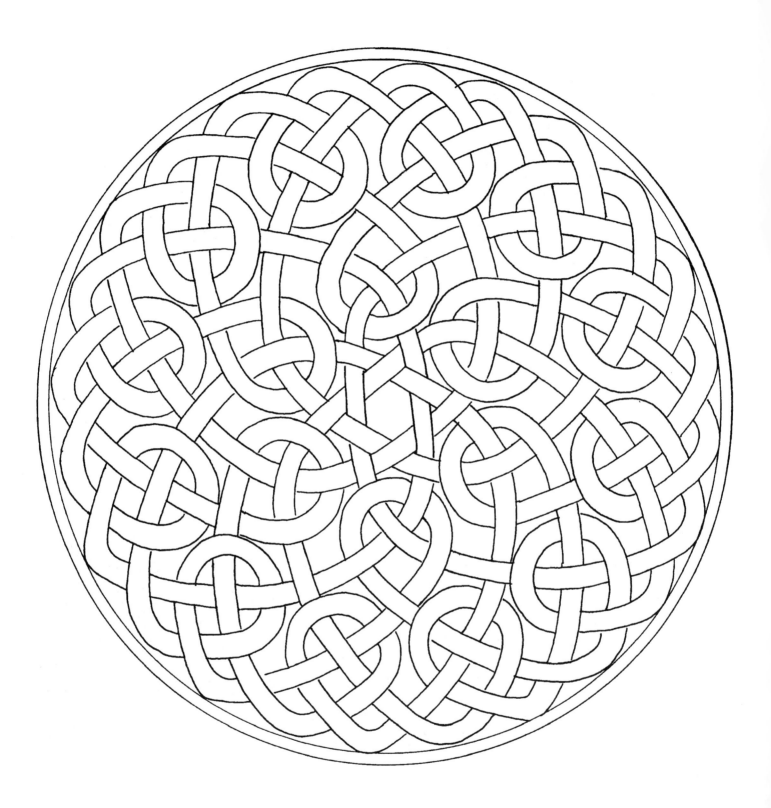

This is another adaptation of the Hilton of Cadboll stone. In colour picture 6 I have put dots within the thread, or band, itself, which gives it more body. You could run a thin line around each edge instead, in a different colour to the one used in the band itself.

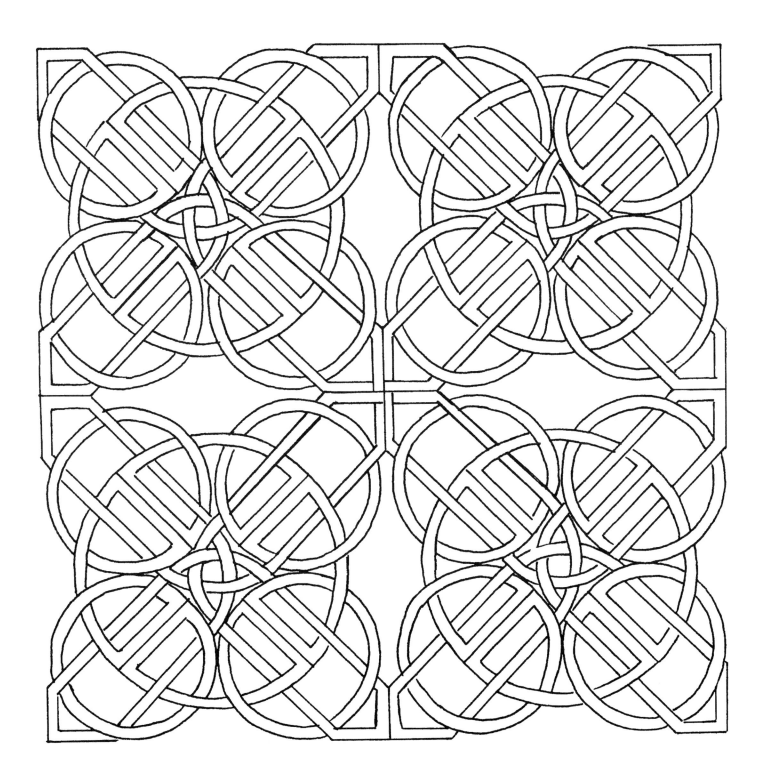

I tried to create a modern feel to this picture, and it has great scope for colouring. I purposely created it using more than one thread so their colours could be different. It is very easy to link them up if you want to have a continuous thread.

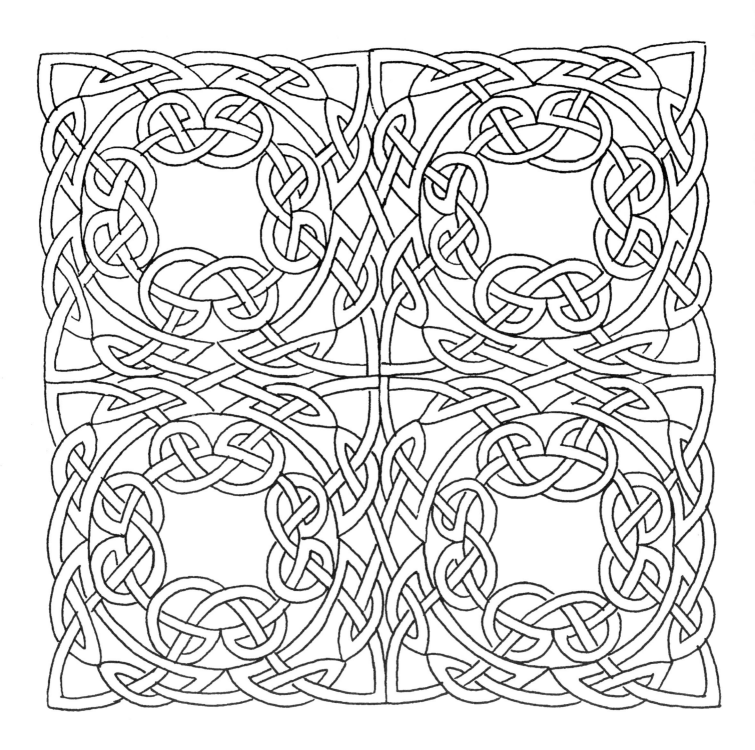

This cross comes from various sources, plus a lot of rough sketching. The centres of the circular pieces at each corner could be adapted to fill in the gap or a colour to represent a jewel could be placed there. You will find that by using different colour schemes that emphasize different sections you can create a variety of pictures from the one pattern (see colour picture 7).

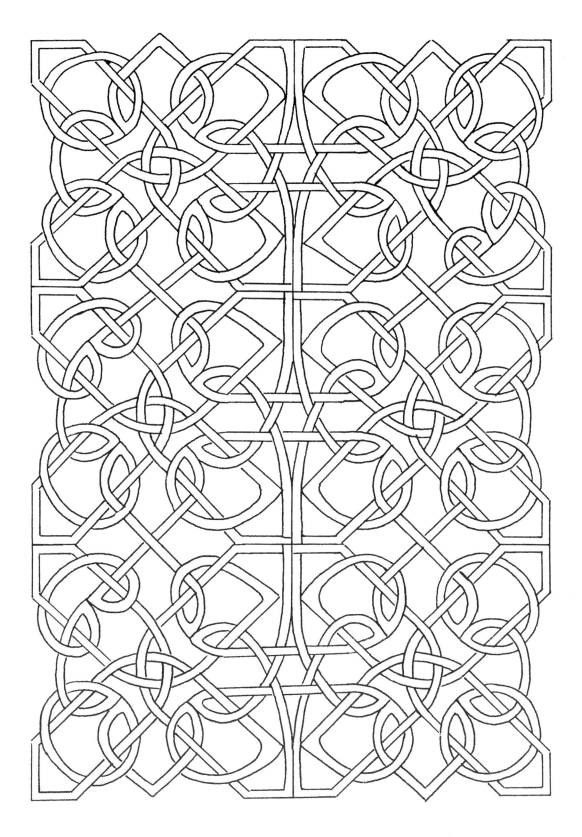

A simple carpet design built up by joining six panels. You could look at ways of making your
own changes; start by tracing off a section you would like to alter so that you are not distracted
by the whole piece.

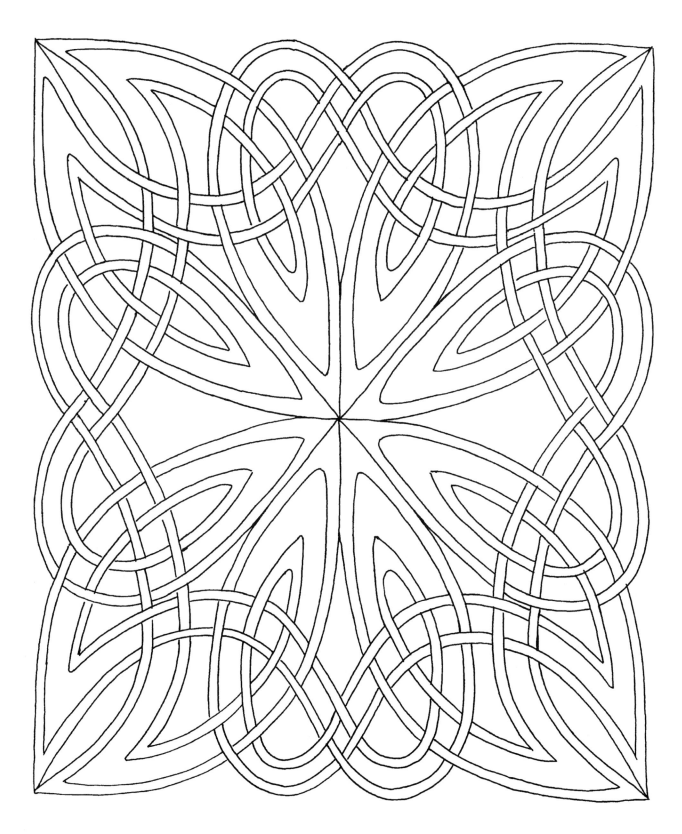

This is an adapted design from a stone cross at Dunafallandy, Perthshire, Scotland. The centre could altered to become a star for easier colouring, and each of the corners could also be reshaped.

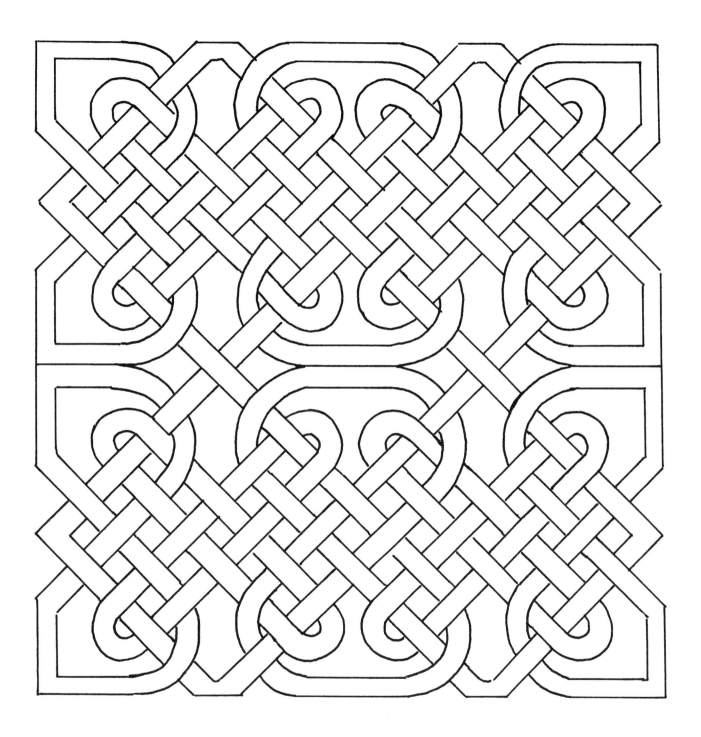

This pattern is not built of one continuous line but can be adapted to one or two lines with practice.
You could also redraw the pattern, turning the single band into two. Remember to link them up.

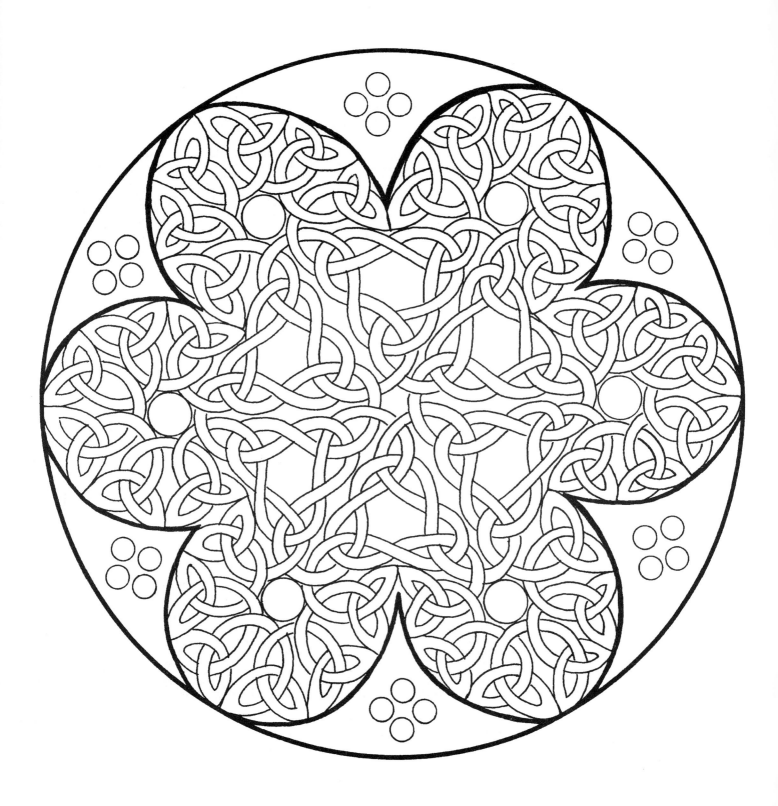

Like the Gordian Knot cut by Alexander the Great, the continuous knot binds the soul to the world
until the thread is broken and the soul is released to begin its spiritual journey.

1

2

3

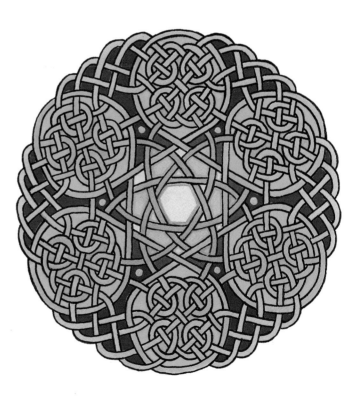

4

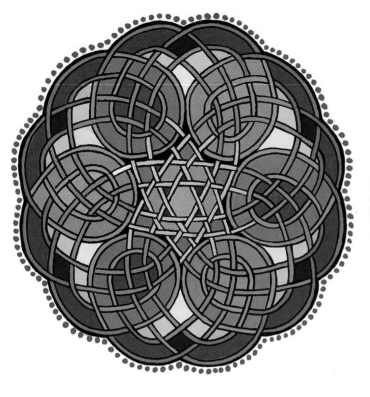

5

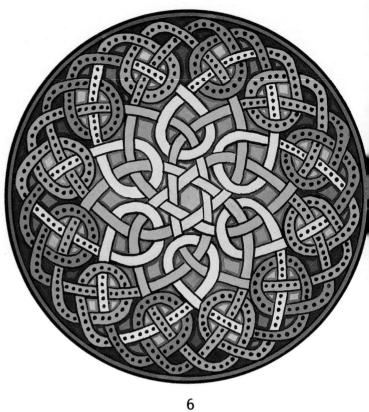

6

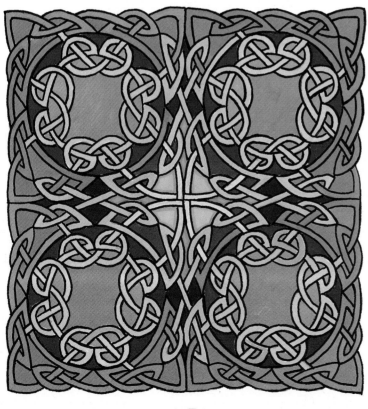

7

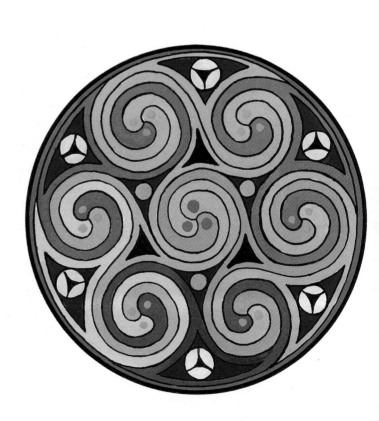

8

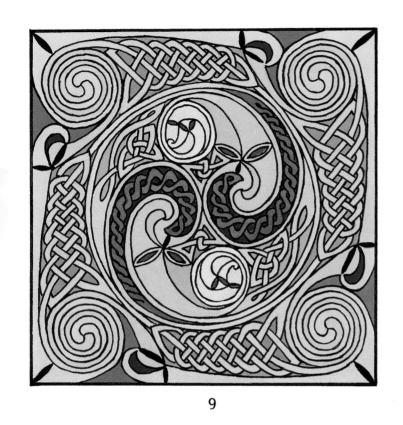

9

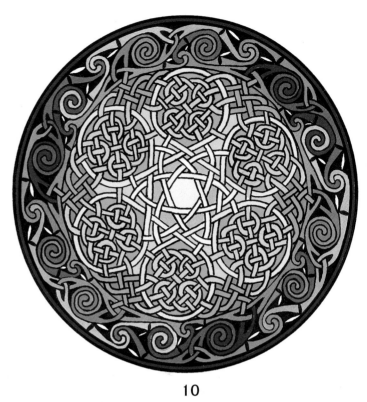

10

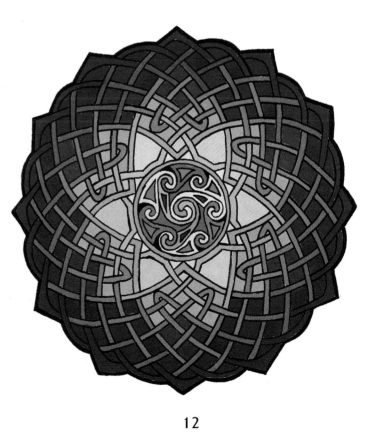

11

12

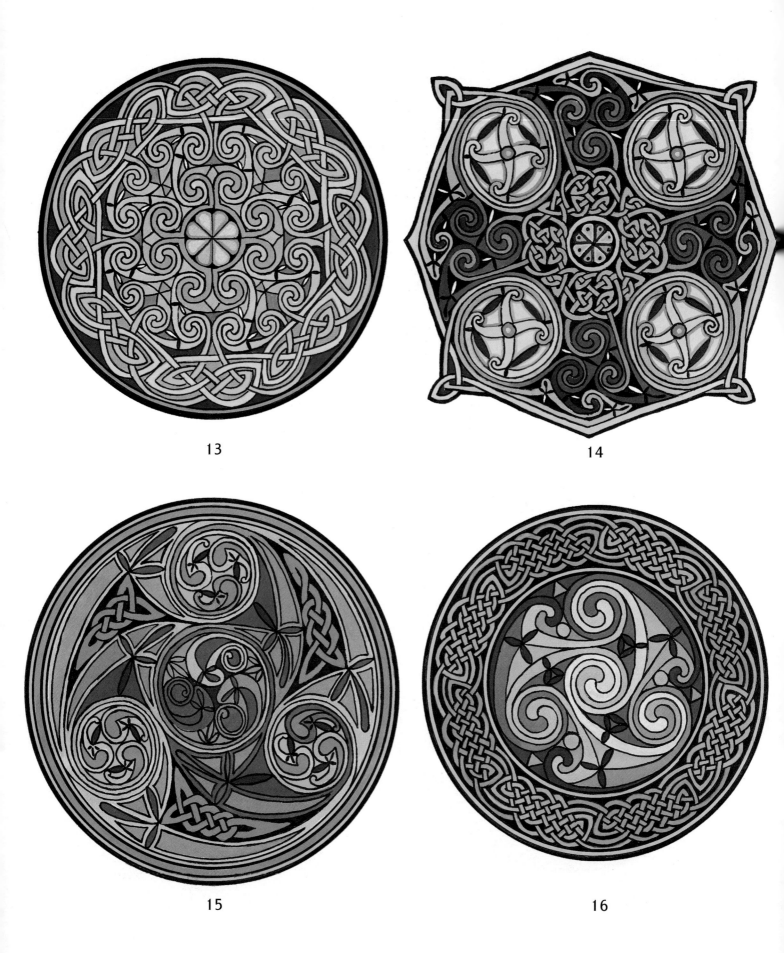

13

14

15

16

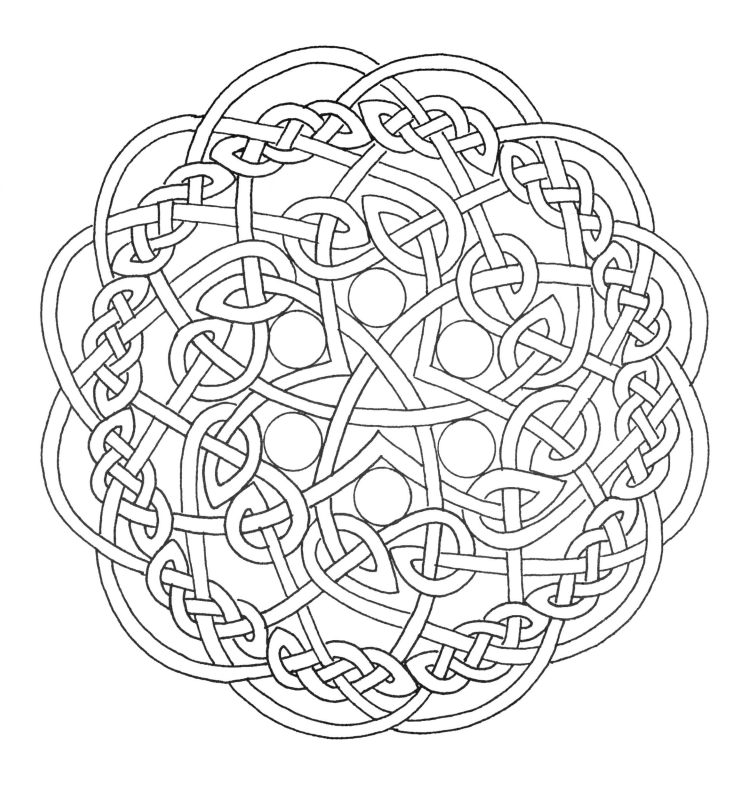

This was created by using two circular bands of simple knotwork and linking them together by laying
two tracings on top of each other, then shifting them into position.

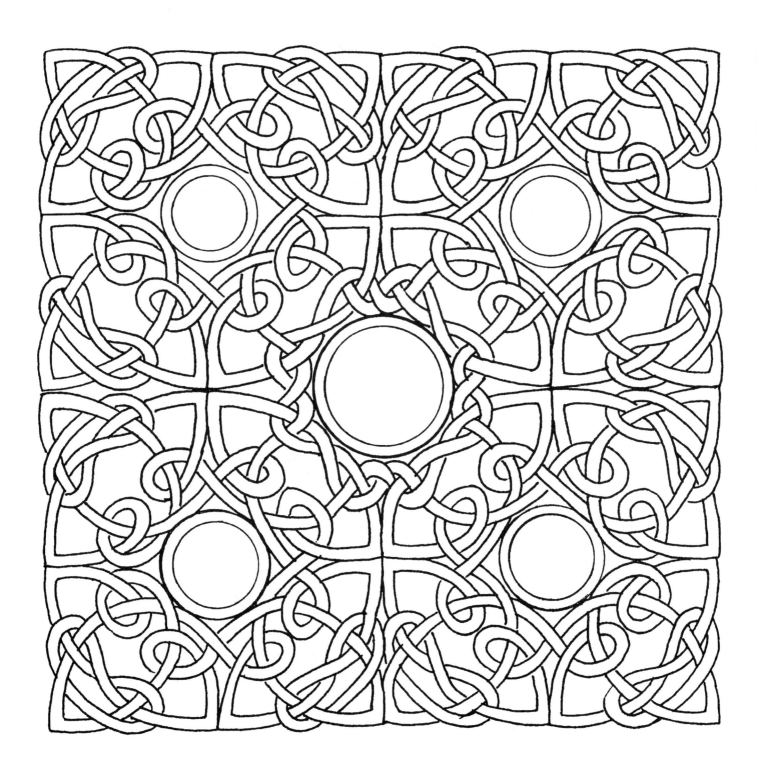

This picture was again built up from a rough doodle of one corner-piece, which I copied
four times to create my first panel. Then I copied that panel four times and joined them up.
There are several alterations that could be applied to the picture, so creating a series of
new images from the one motif.

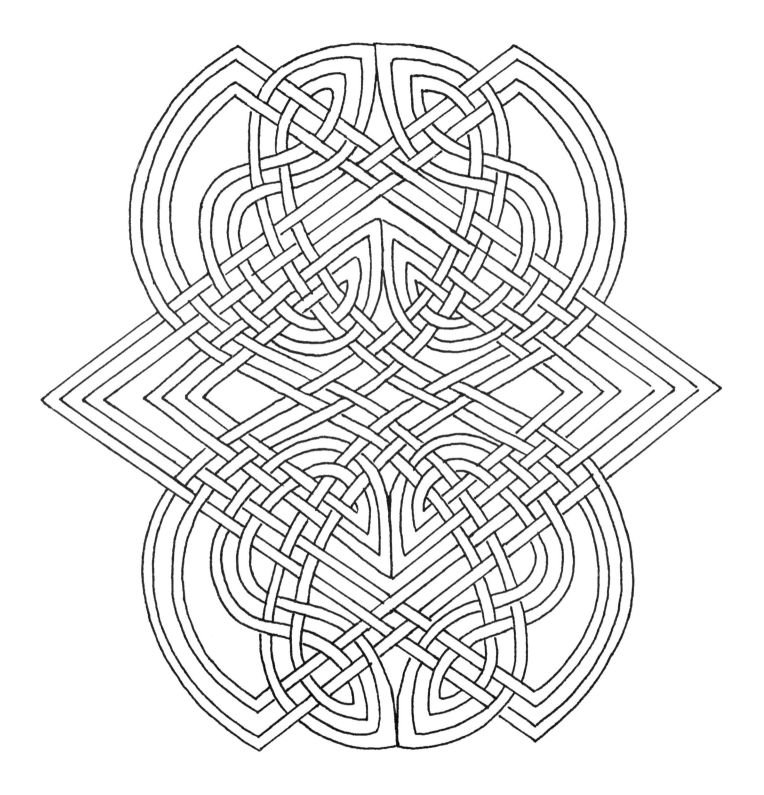

This panel can easily be joined to the top and sides to create a carpet design. If you join the straight lines you shouldn't have too much of a problem with the over- and under-sequence and the continuous band. However, it is sometimes interesting to construct the picture with two or more coloured bands running around it.

SPIRALS

HEN EARLY man observed the beauty of nature's spirals it is not surprising that the spiral would become a potent symbol for creation and growth. It is the only decorative motive used in Christian Celtic art proven to have its roots in the preceding pagan period, the best examples of which are found on stone monuments such as the decorated kerb-stone at the entrance to the burial chamber at Newgrange, Co. Meath, in Ireland, which dates from around 3000 BC.

One-coiled spirals can be found in the art of most peoples of Europe, Asia, Africa, Polynesia and the Americas, and the Egyptians used spirals as all-over motifs from around 3000 to 1500 BC. It was the Celts, however, who found the method of making two, three and four, or more, coils and so developed the spiral further. This art form would later be put to good use on the Aberlemno Churchyard stone in Angus, Scotland, the stones of Hilton of Cadboll, the fine metalwork of the Tara brooch and Ardagh chalice and later in decorated books. The spiral was the earliest decorative ornament to be used in Celtic art and, by the mid-tenth century, was the first to disappear.

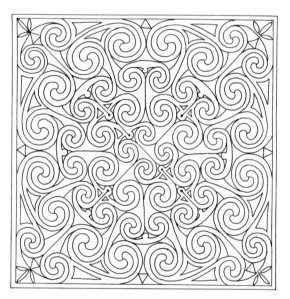

Spiral panel from the Shandwick stone, Ross-shire, Scotland.

In the Neolithic world, by passing a spiral barrier (like the entrance stone to the Newgrange burial chamber) the initiate was led into the inner sanctuary. This was the necessary passport in the journey of the sacred dance, which led through the labyrinth to the sacred realms beyond the centre. The labyrinth created and protected the still centre, allowing entry to its knowledge only in the correct way, through initiation. In ancient lore, before the knowledge can be imparted, old preconceptions must be discarded and the traveller must re-enter the preformative state of the womb. At the centre, there is complete balance: the point where heaven and earth are joined. The descending gyre of heaven is the materialization of spirit into matter, maintaining a state of balance in the initiate inwardly and outwardly – a state of perfect being. In the sacred dance, we mirror the macrocosmic order of the heavens, the gyratory movement representing the whirling of the stars above the earth. As we wind, we create within ourselves a still centre and apprehend the being of the universe into our being. As we unwind, we turn our spirit back to its divine source. The early Celtic saints continued this tradition by using a rock cavity for meditation and prayer.

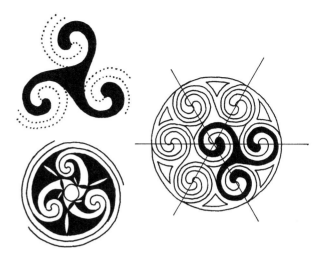

The archetypal symbol of power, the three-in-one, was the *triskele*, which was later called the 'Secret Fire' by the alchemists, and was depicted all over the Celtic world. It has three arms springing from a common centre, and the three-legged symbol of the Legs-o'-Man evolved from this pattern. A related four-legged version became the swastika.

Having had many experiences of the movement from one world to another it is easy for me to accept the continuation of existence, although in different body forms. The Celts were firm believers of this ability and most of their myths and legends deal with this journeying. Our movement through the experiences of life, death and rebirth is symbolized in the ever-changing directional flow of the spiral. The rising consciousness can be seen as reincarnation of life-form(s) that progress as one's thinking becomes more spiritual. The early Christian monks who had absorbed some of the teachings of the pagan druids knew of the 'spirals of life'. It was only at a much later date that this ancient knowledge was deleted from the teachings of religious aspirants and the Celtic knowledge forgotten. The ancient writings of Sanskrit also referred to thought-energy and waking consciousness, embodied in Kundalini, the fiery serpent.

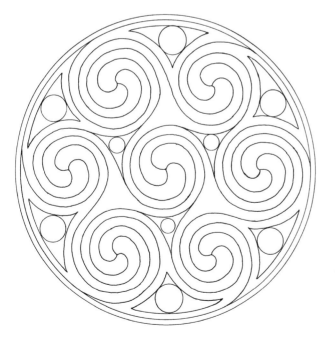

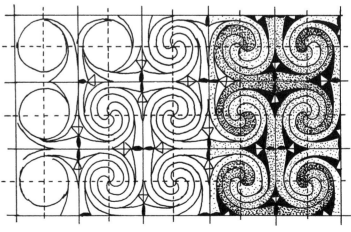

This shows a simple way to construct a spiral border pattern.

The spiral design above comes from the cross-slab at Aberlemno, Angus, in Scotland.
A good working understanding of the use of the *triskele* is needed to conceive such a design.
It is sometimes easy to get confused while colouring spiral patterns and end up with the same
colour arriving in the centre twice. Keep checking the path. For a coloured version of this design
see colour picture 8.

Each individual has their own spiral that is unique to them; no one person can tread its pathway, or swap it for another. However, we sometimes recognize another person on a similar spiral to one's own – but never the same spiral. You should not live in regret for mistakes made or be too hasty to reach the end of a particular spiral of experience. If you depart from your spiral too early you will rejoin it again at a later date at the same place, for what goes around, comes around – there are no short-cuts to the 'spirals of life' and their purpose.

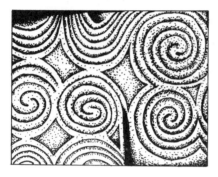

Carvings from the Newgrange burial chamber, Co. Meath, Ireland, c. 3000 BC.

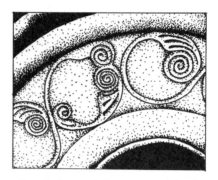

Detail of one of the two roundels of a second-century BC bronze shield cover from the River Witham near Washingborough, Lincolnshire.

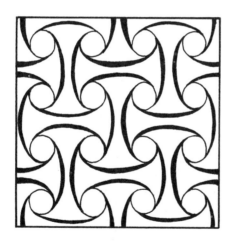

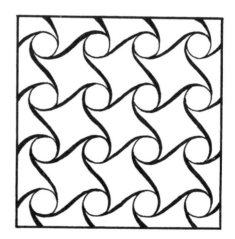

Although, at first glance, the construction of spiral patterns looks complicated, the geometric pattern is very simple. First, lay out a series of circles of any size, leaving the same distance between each of them. These can then be connected using either C-T or S-shaped curves.

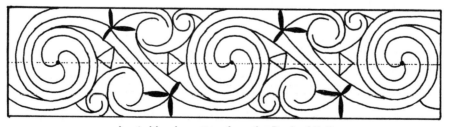

A spiral border pattern from the Book of Kells.

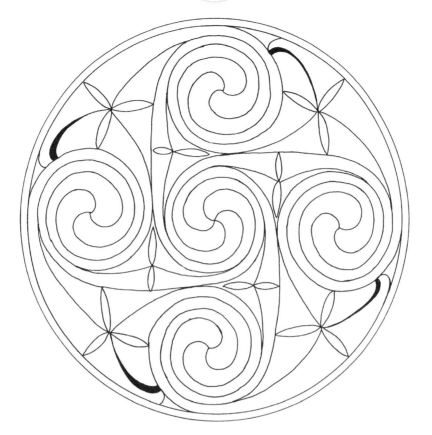

A four-coiled spiral from the Book of Kells.

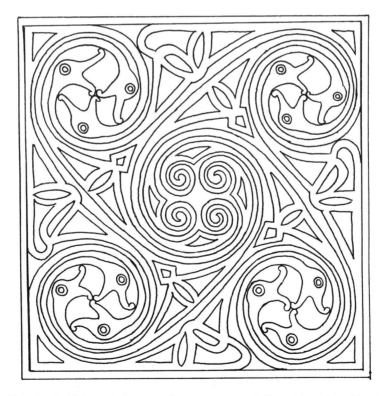

The simple bird-head centres to these spirals are similar to those found in the
Book of Kells and other manuscripts.

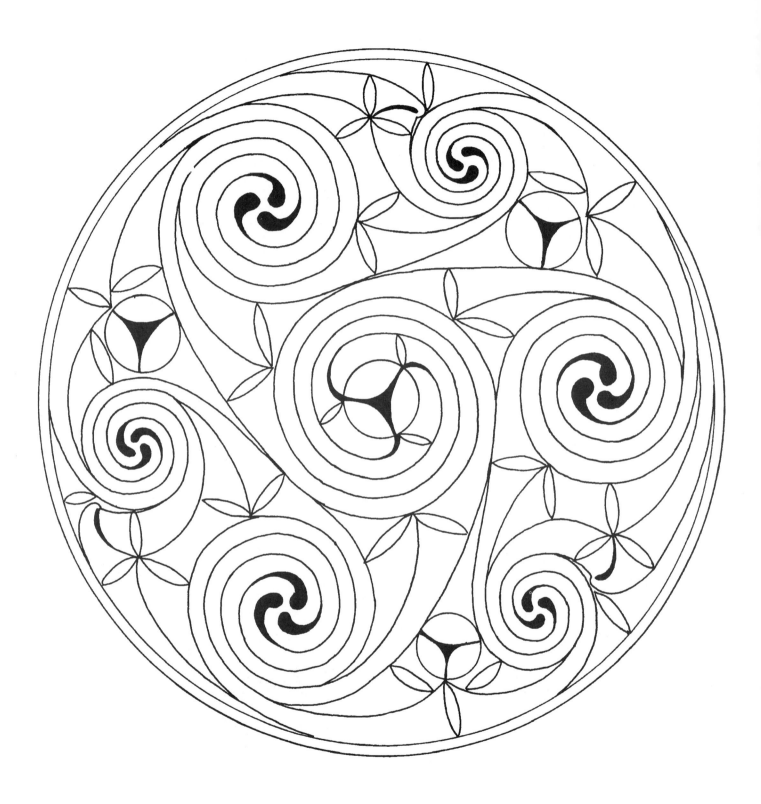

This spiral disc from the Book of Durrow achieves a sense of balance by its contrasting rotation of
clockwise and anti-clockwise motion.

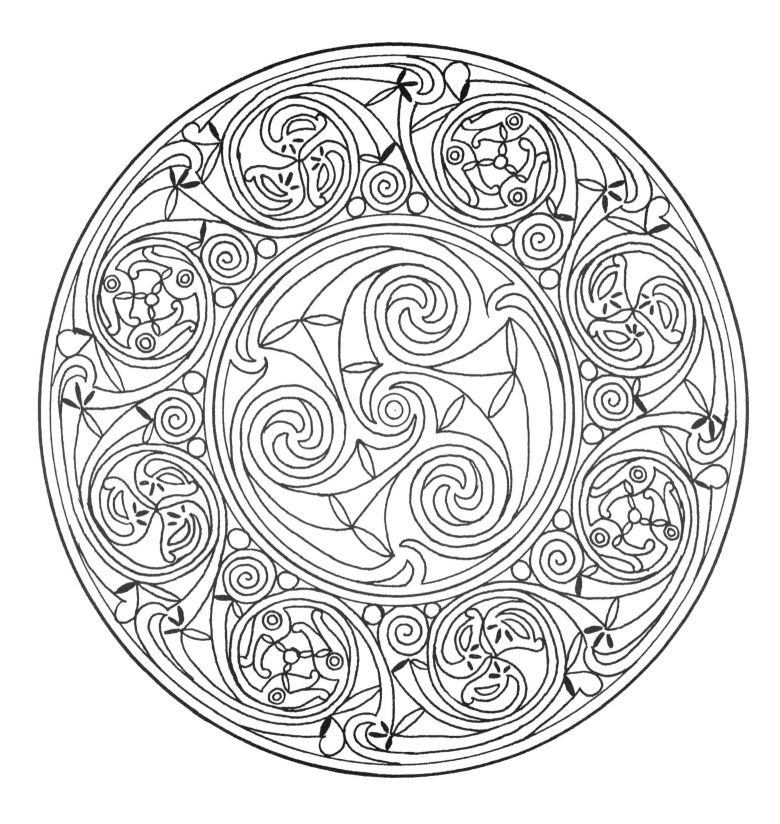

In *Symbolism of the Cross* Derek Bryce tells us that the symbolism of the spiral is that of the 'motionless mover', the Most High God in the centre, around whom all things revolve. The spiral emphasizes the movement.

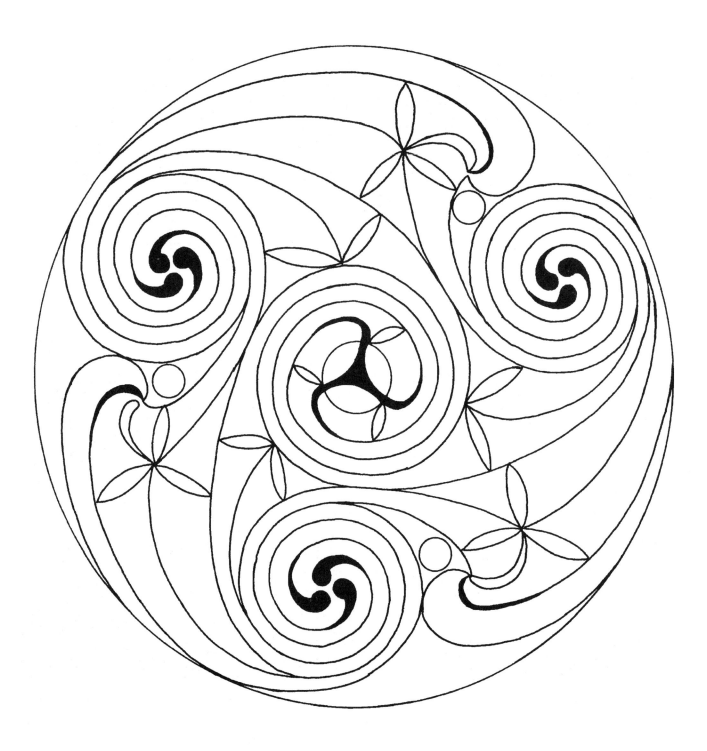

The spiral designs in the Books of Durrow and Kells and the Lindisfarne Gospels show the expertise
of the illuminator and the transformation of their construction from the early spirals carved on stone
at Newgrange in Ireland.

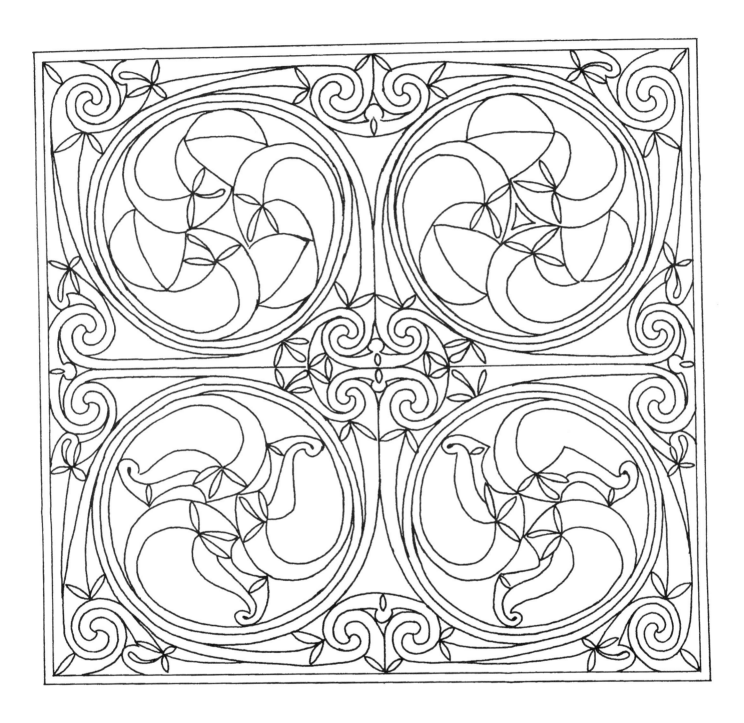

A centre panel from a carpet page in the Lindisfarne Gospels, AD 698.
The large areas within the four spirals offer the opportunity to turn them into zoomorphic centres,
with possibly bearded heads, dogs or birds.

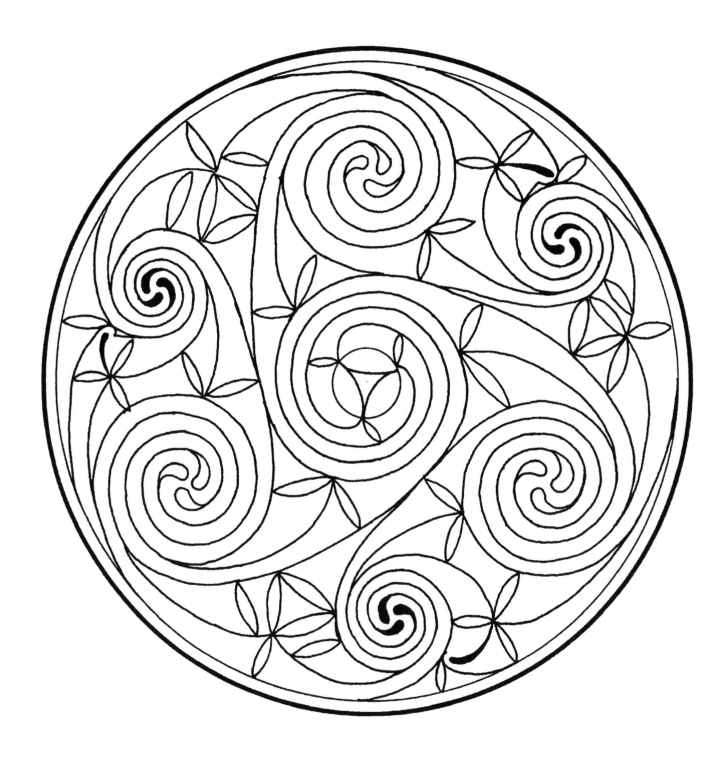

The spiral has always been a very magical symbol representing the evolution of the universe and growth in nature, and is associated with primitive dances of healing and incantation. These offer escape from the material world, and an entrance into the otherworld through the 'hole' symbolized by the mystic centre.

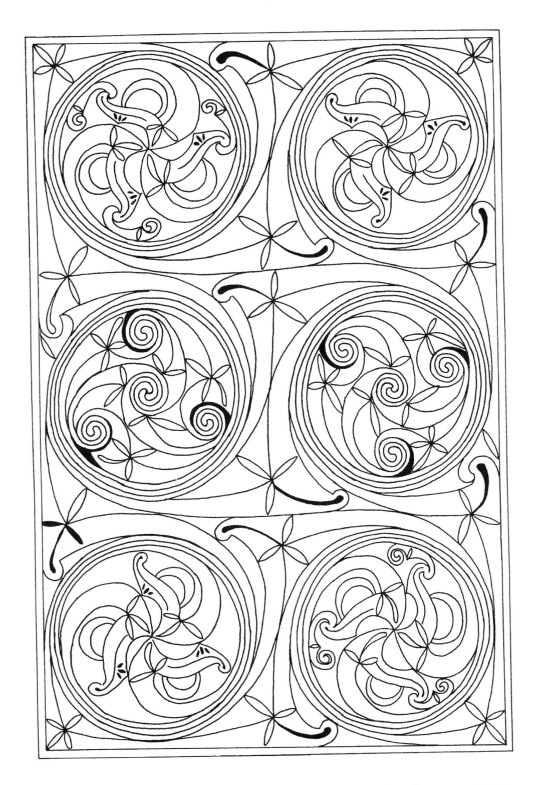

In Neolithic times, passing a spiral barrier seems to have been necessary in order to step within the inner sanctuary of a stone burial chamber, such as the entrance stone blocking the entrance to the tomb at Newgrange, the passage beyond symbolizing the soul moving from death to find rebirth at the still centre. The inner chamber was used for both meditation and initiation, and the early Celtic saints continued this tradition by using a rock cavity for meditation and prayer. This spiral design is a panel from the Lichfield Gospels, eighth century AD.

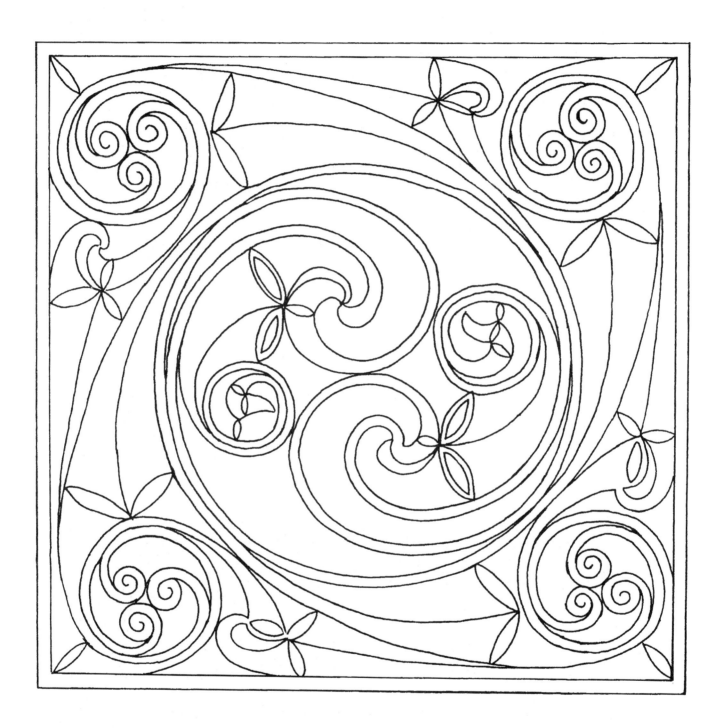

There is a continuous line of evolution of the spiral in three-dimensional art in Ireland and the British Isles from prehistoric times. Though the single-coil spirals are found in many parts of the world, it was the Celts who developed them. They first used them on themselves, their jewellery, weapons and ornaments for the horse. Later, such designs are found in the masterpieces of metalwork and the decorated books of the early Christian era. This is a panel from the Lindisfarne Gospels.

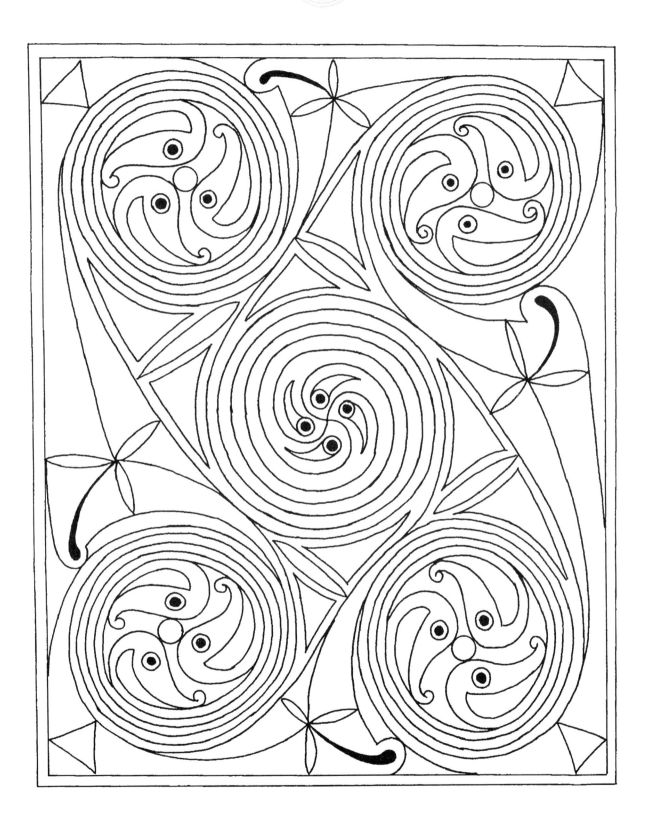

The centres of the spirals in the Book of Kells and the Lindisfarne Gospels are generally coloured red, purple, blue or black, with the spiral itself either painted in a light colour or left unpainted altogether.

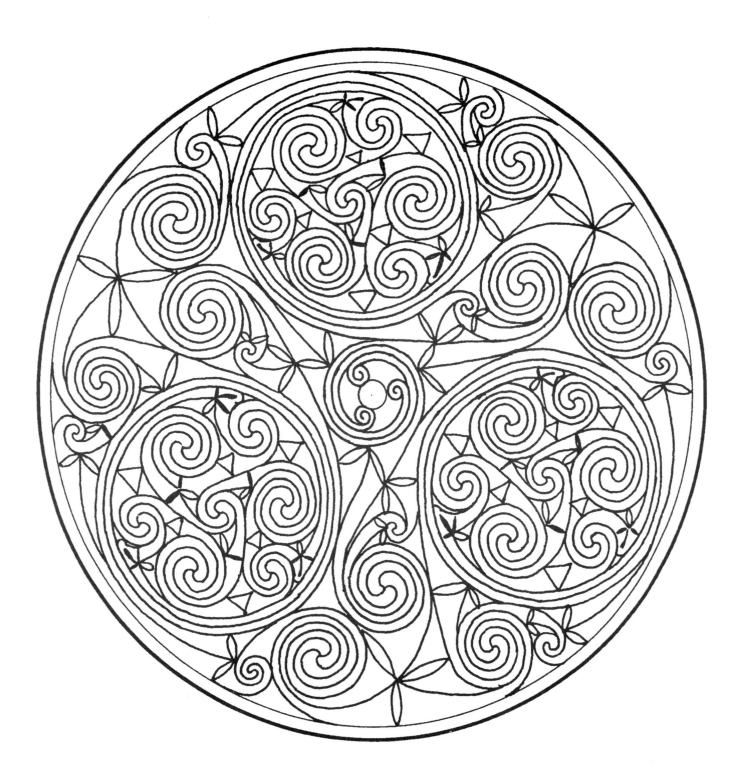

With very few exceptions (if any) the constructions of insects, birds and animals are made by circular motions. From the beginning the earliest symbol used by man was the circle and then the spiral. The spiral was both a symbol and an ornament, and its constructional methods rapidly became magical. It could be constructed either to the left or the right, sunwise or anti-sunwise, thus becoming a symbol for either negative or positive energy flows.

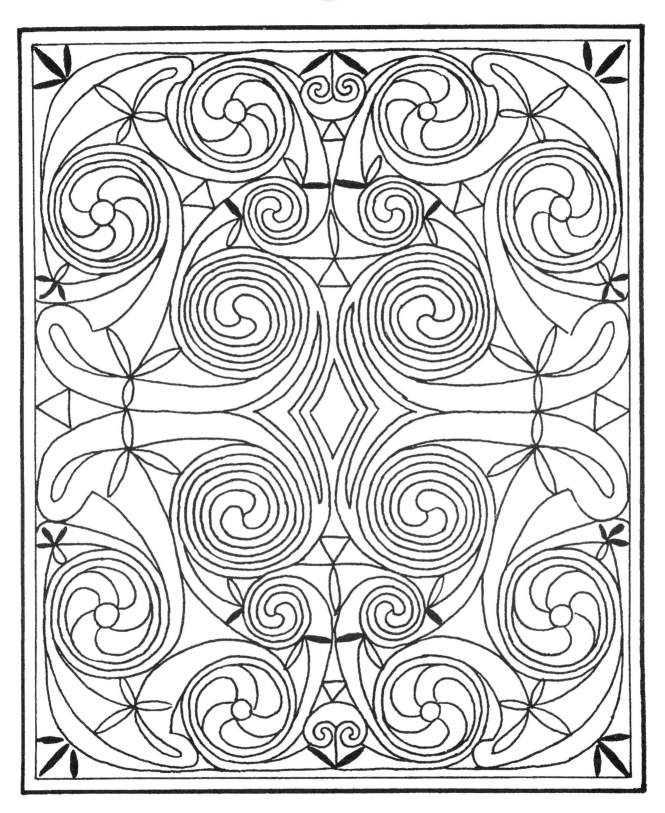

I personally find more pleasure in creating spiral designs than knotwork and key patterns, and get great satisfaction winding and unwinding the coils from one to the next. The most difficult part is keeping the bands even as they sweep around. I hope that with practice and patience you will try designing them yourself.

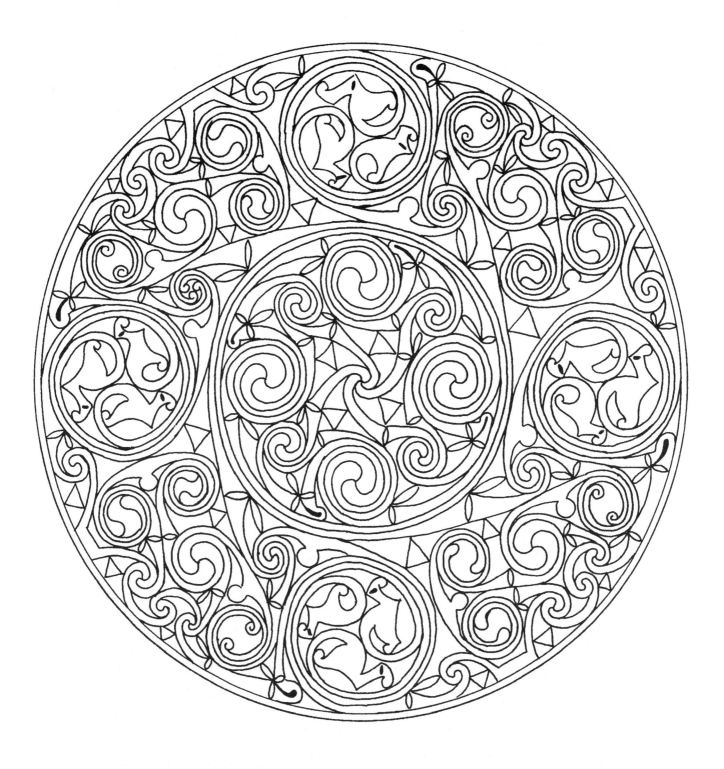

The Book of Durrow, the Lindisfarne Gospels and especially the Book of Kells are a great treasury of ideas when creating spiral patterns. The pattern above originated from the Book of Kells, with a few adaptations of my own. When coloured, such designs can look like jewels on the page.

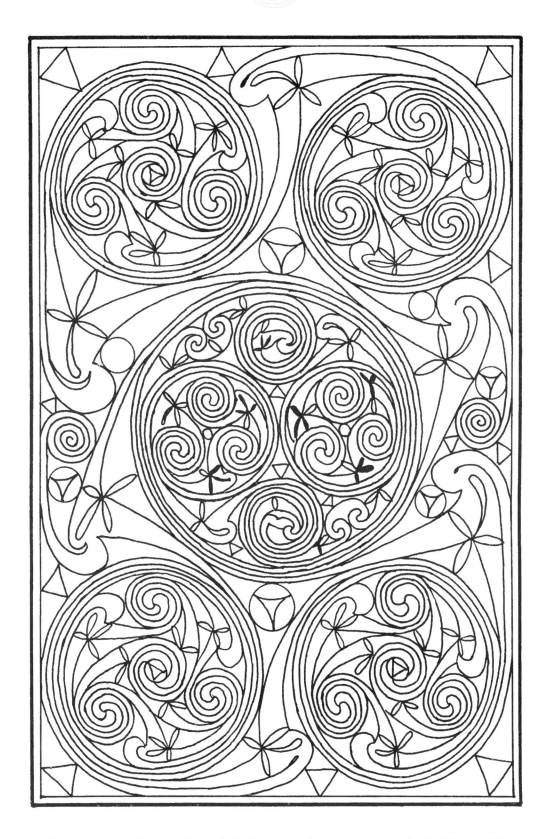

This picture is a redrawing of part of a badly damaged carpet page in the Book of Durrow. This manuscript was written around AD 680, and is the earliest of the surviving fully illuminated insular gospel-books. The background colour of the original is black with yellow, green and red spirals.

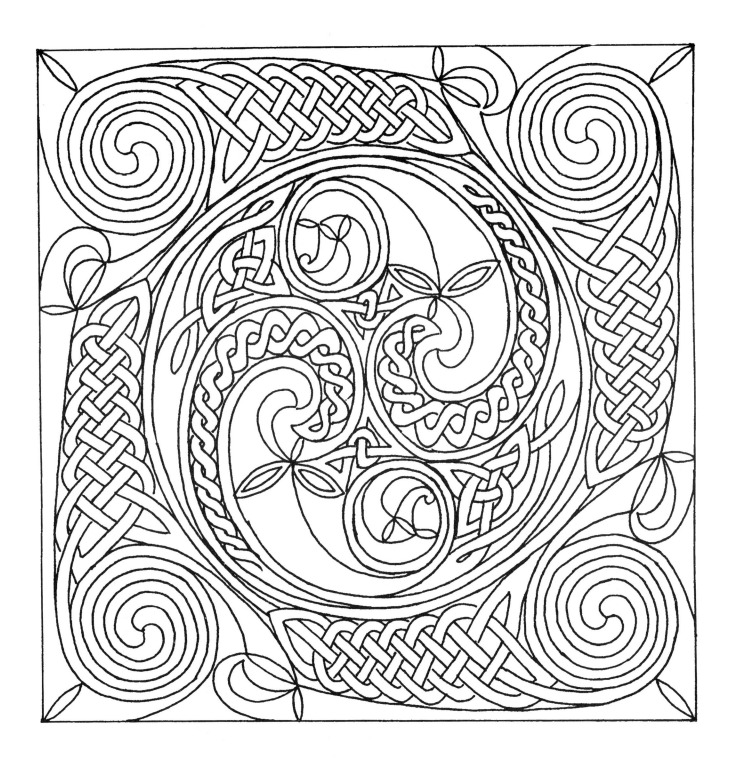

In his book *Celtic Design: A Sourcebook of Patterns and Motifs*, Ian Zaczek suggests that, because of the absence of human remains at the passage grave at Gav'rinis in Brittany, the place was as much a ritual centre as a tomb, and adds that it was carefully aligned — like Newgrange in Ireland — with the winter sunrise. The spirals carved around the entrances of these sites are thought to have been solar symbols, representing the sun's movement across the sky. The centre spiral of this image could be filled with extra decoration to create a feeling of movement and colour can make the design look almost three-dimensional (see colour picture 9).

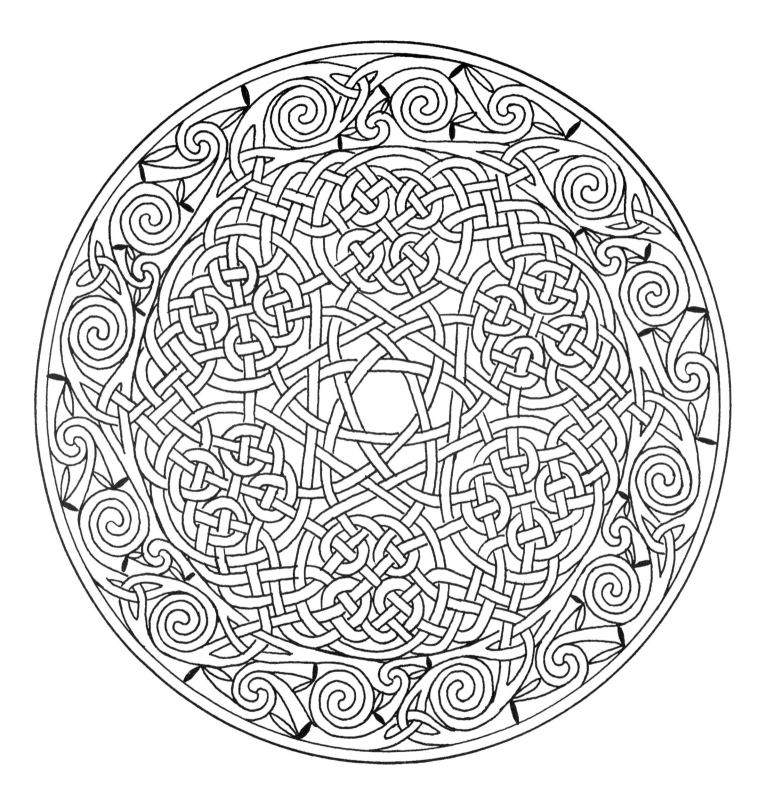

Here the bands of the spiral outer border are turned into knotwork. You will have to take great care following the line from the spiral into the centre pattern when colouring. The centre of the design could be enhanced with a six-petal flower and colour adds vibrancy (see colour picture 10).

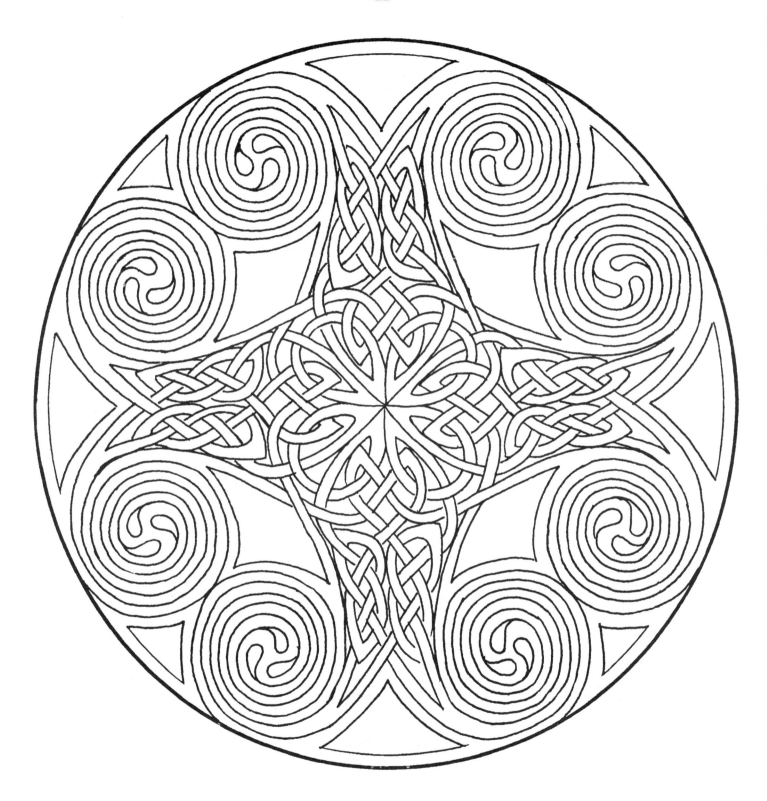

In the Hiberno-Saxon manuscripts the background colour to knotwork panels varies from blue, purple, green, red and black, or a mixture, depicting certain sections of the pattern. Try various colour schemes until you are happy with the result. Perhaps you could start with a lighter colour in the middle, and darken the background and pattern as you move out from the centre (see colour picture 11).

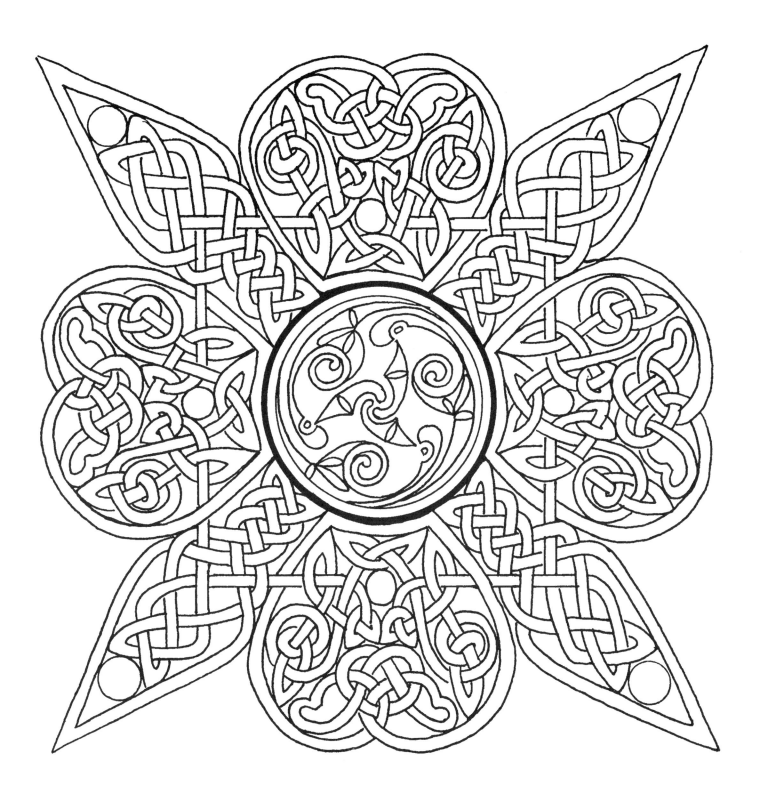

The cross in the picture is an adaptation of part of a stencilled decoration that was created by Sister Concepta Lynch, O.P., in an oratory of the Dominican Convent at Dun Laoghaire, Co. Dublin, Ireland, between 1920 and 1936.

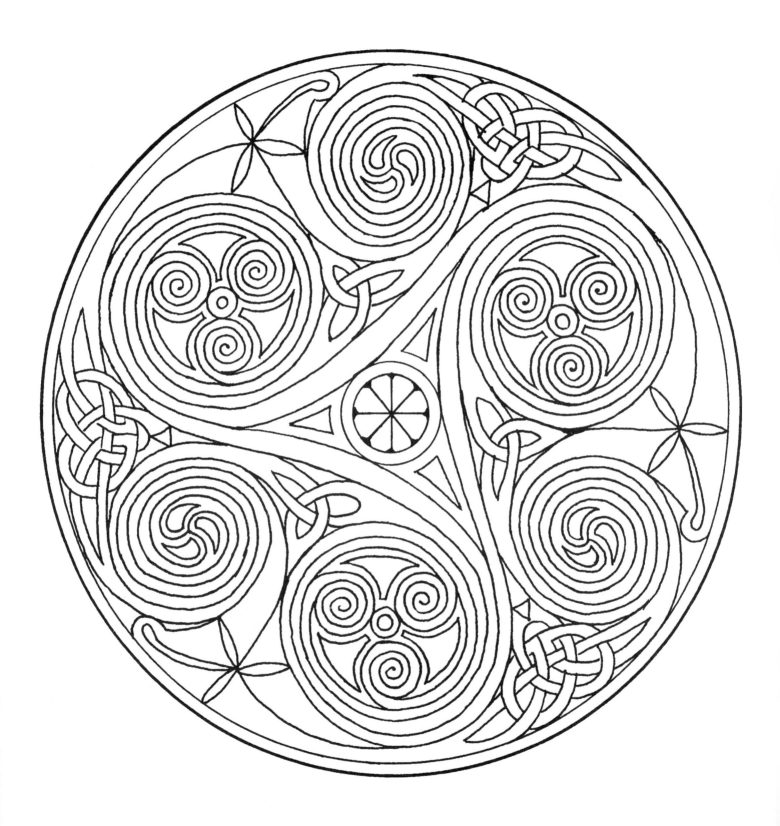

I have used 'S' and 'C' spirals in this picture and added knotwork in the design to help to fill up the spaces between the coils.

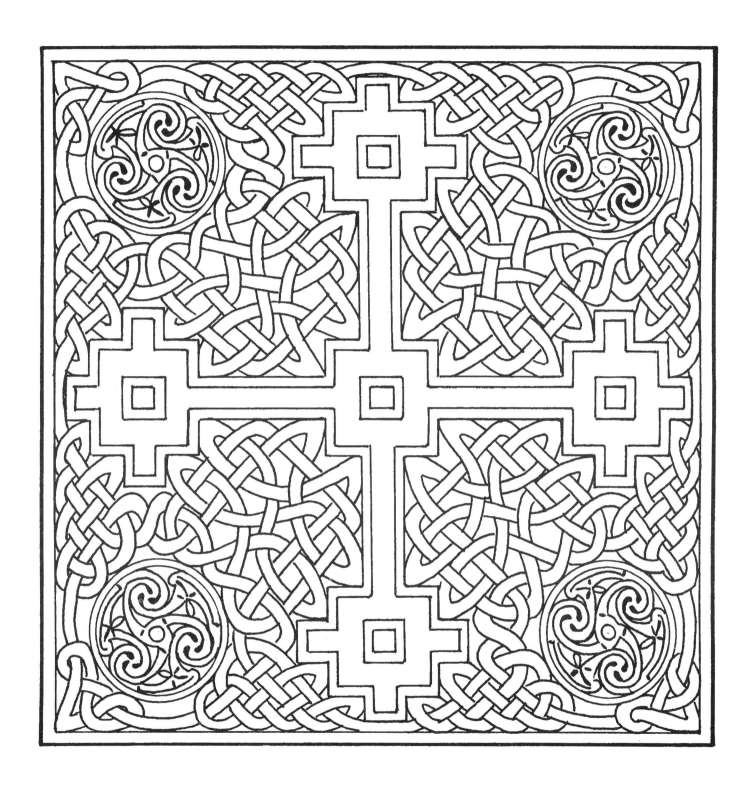

This is a simplified adaptation from the double-armed cross carpet page in the Book of Durrow. I also included spiral discs in each corner to replace the more intricate knotwork crosses of the original.

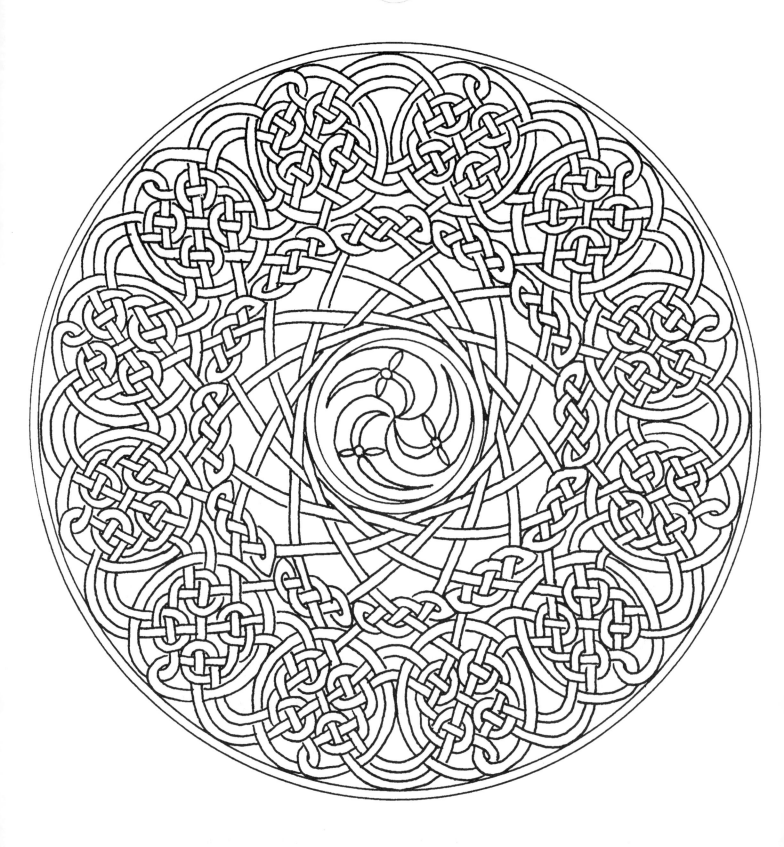

Though the spiral at the centre is not actually connected to the knotwork design around it, I felt the picture had possibilities with the sunray effect radiating from the central disc.

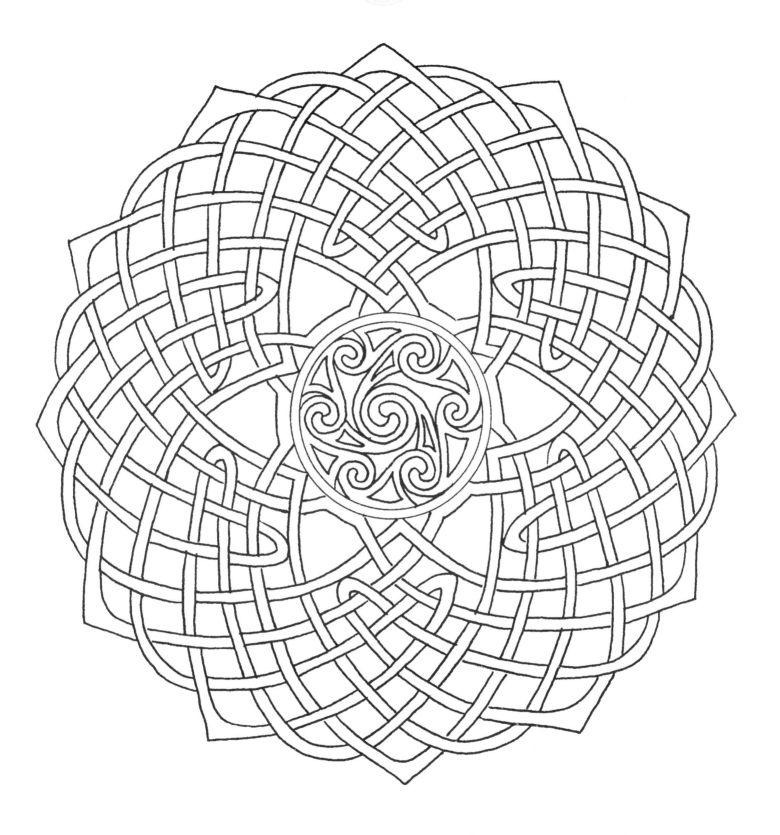

Here is another disc not connected to the outer pattern, but I felt the overall effect was pleasing. The centre could be linked. Why not give it a try? You could also add circles to each corner of the inner star. Colour can radiate outwards from light to darker tones or vice versa (see colour picture 12).

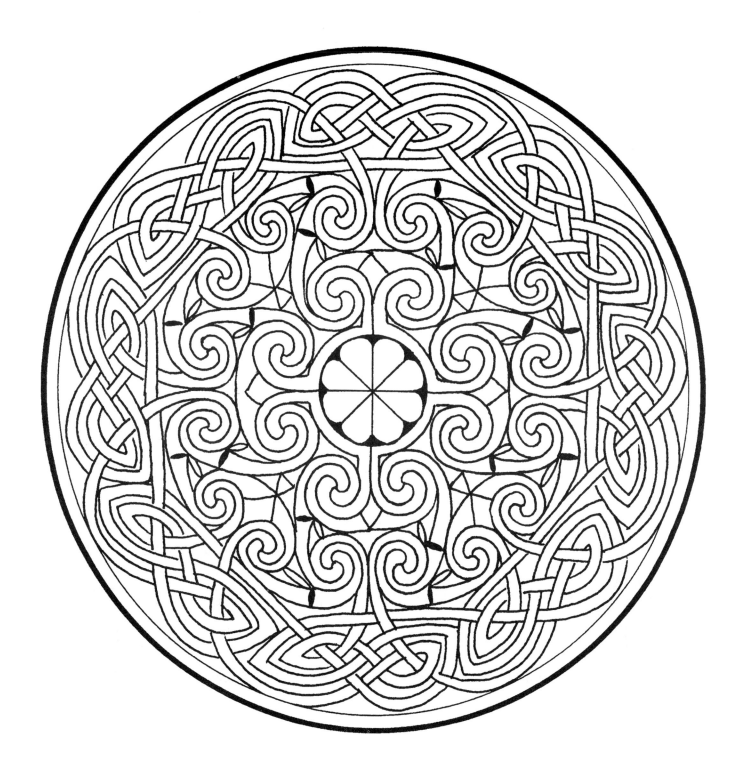

The central spiral pattern comes from a panel on the Hilton of Cadboll stone, Ross-shire, Scotland. I
have sometimes spent hours trying to link a knotwork to a spiral pattern and have ended up
throwing it away, but when it works and is coloured it can be very pleasing (see colour picture 13).

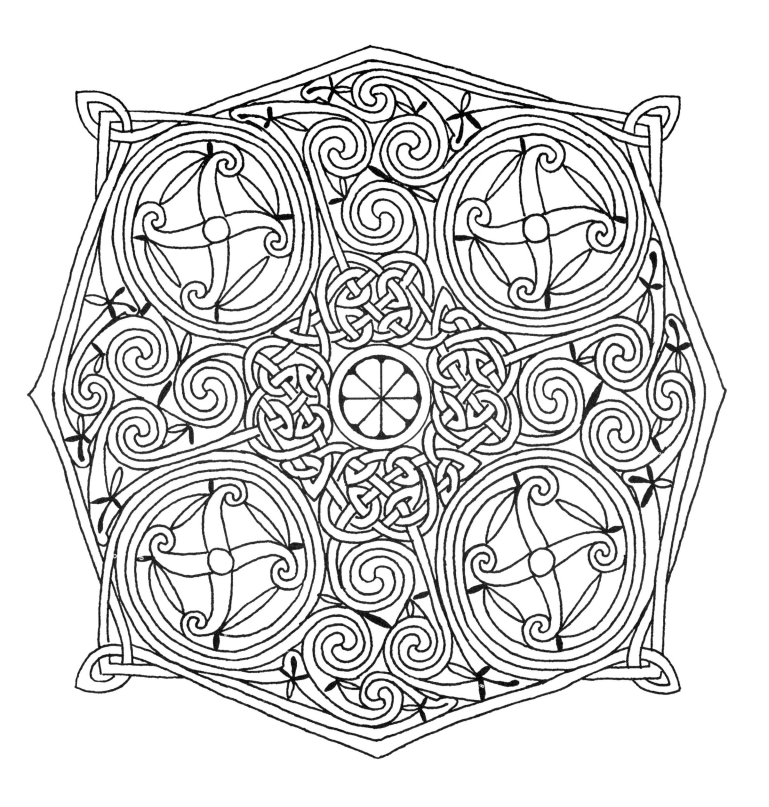

The outer edge of the picture is reminiscent of the artist Archibald Knox whose work has greatly influenced me over the years. If reworked, this picture could be enhanced with either bird or dog heads at the four corner spirals. This pattern turned point-to-point can make another cross design, using the spirals as each arm, and colour makes it stand out (see colour picture 14).

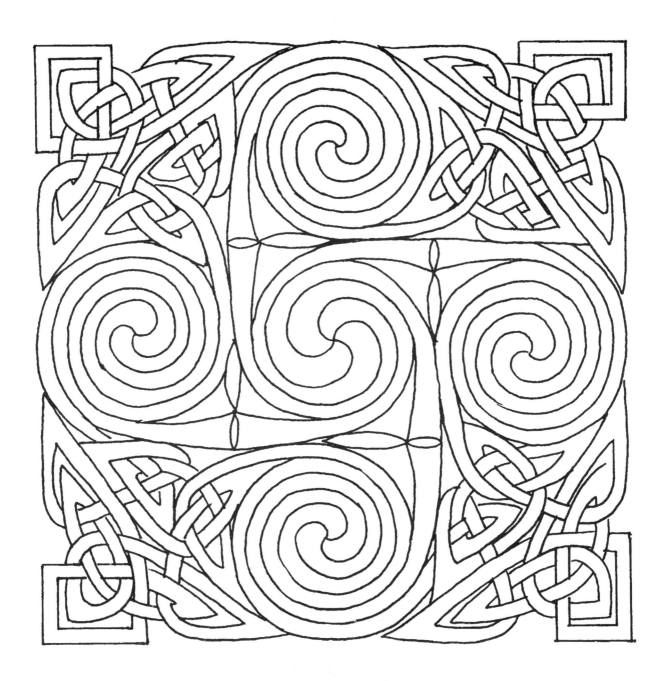

This panel could be easily joined to others to create a larger carpet design; there is no one continuous thread, so tying in shouldn't be too difficult. You could create a different central knotwork pattern, perhaps in the shape of a cross.

furtHer reaDINg

BOOKS BY COURTNEY DAVIS

The Art of Celtia, Blandford, 1994.

Celtic Art of Courtney Davis, Spirit of Celtia, 1985.

The Celtic Art Source Book, Blandford, 1985.

Celtic Borders and Decoration, Blandford, 1992.

Celtic Design and Motifs, Dover, 1991.

Celtic Illumination: The Irish School, Thames and Hudson, 1998.

Celtic Image, Blandford, 1996.

Celtic Initials and Alphabets, Blandford, 1997.

The Celtic Mandala Book, Blandford, 1993.

Celtic Ornament: Art of the Scribe, Blandford, 1996.

The Celtic Saint Book, Blandford, 1995.

The Celtic Tarot, Aquarian, 1990.

Key Patterns and Animals: A Celtic Art Workbook, Blandford, 1999.

King Arthur's Return, Blandford, 1995.

St Patrick: A Visual Celebration, Blandford, 1998.

A Treasury of Celtic Designs, Constable, 1998.

You can view the art of Courtney Davis on his web site: celtic-art.com

OTHER BOOKS OF INTEREST

Allen, J. Romilly, *Celtic Art in Pagan and Christian Times*, Bracken Books, 1993.

Bain, George, *Celtic Art: Methods of Construction*, Constable, 1951.

Bain, Ian, *Celtic Knotwork*, Constable, 1986.

Bryce, Derek, *Symbolism of the Cross*, Llanerch Enterprises, 1989.

Meehan, Bernard, *The Book of Kells*, Thames and Hudson, 1994.

Zaczek, Iain, *Celtic Design: A Sourcebook of Patterns and Motifs*, Studio Editions, 1995.

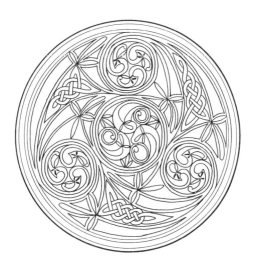

The number three was important to the Celts and symbolized, among other things, mind, body and spirit. You can use colour to emphasize the three-in-one design (see colour picture 15).

INDEX

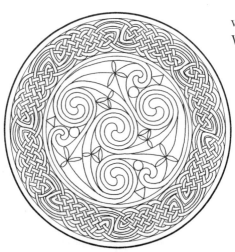

The inner spirals might benefit from yin and yang symbols being added to them, and perhaps dots could stretch along the scrolls. Colour gives the design a jewel-like quality (see colour picture 16).